LOVE IS OUR MISSION

love is our mission

POPE FRANCIS
IN AMERICA

Cover photos: CNS photos—Bob Roller (front); Paul Haring (back)
The credits on pages 126-127 constitute an extension of this copyright page.
Copyright ©2016, Catholic News Service / United States Conference of Catholic Bishops.
All rights reserved.

Published by Franciscan Media
28 W. Liberty St.
Cincinnati, OH 45202
www.FranciscanMedia.org

Printed in the United States of America.
Printed on acid-free paper.
16 17 18 19 20 5 4 3 2 1

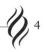

Contents

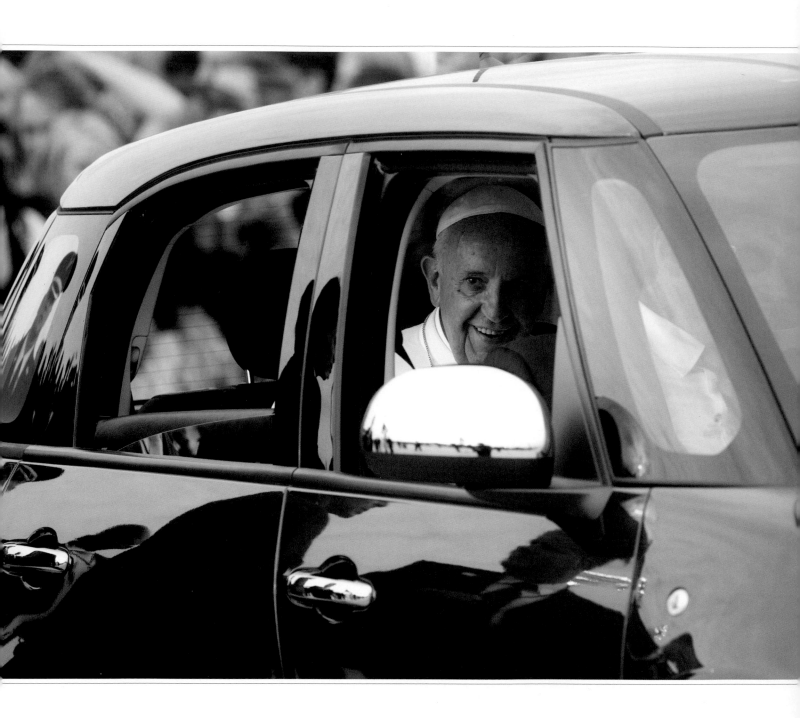

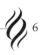

Foreword

GOD BLESS YOU!

What an honor it was to have our Holy Father come to the United States and share his joyful witness with us! I found that he came to our country both as a pastor to be with his people and as a prophet to call us to greater conversion to Christ. His profound words and beautiful gestures pointed the way for each of us to more joyously and faithfully serve each person in the name of Jesus.

He visited with the powerful and with the poor, but, in a special way, he called us to serve those on the margins, those who are often overlooked or even thrown away. In the rich tradition of our Church, this includes the migrants and refugees looking for hope and peace in a new land, the poor, the elderly, the unborn child in his or her mother's womb, the person who for various reasons is distant from the Church, the sick, the prisoner, the man or woman struggling with hopelessness. Pope Francis encouraged us to walk alongside them and generously offer life and hope.

Pope Francis did not come as a politician. I hope we, too, are encouraged to rise above political agendas and, together, seek the common good. I love that when we are truly seeing Pope Francis, we see that he is joyfully pointing us toward Jesus.

I am grateful for those who put together this commemorative book. I believe we will be reaping the spiritual fruits of the Holy Father's visit in the Church and, I hope, in American society at large for many years to come.

May God bless you,

Archbishop Joseph E. Kurtz
Archbishop of Louisville
President, U.S. Conference of Catholic Bishops

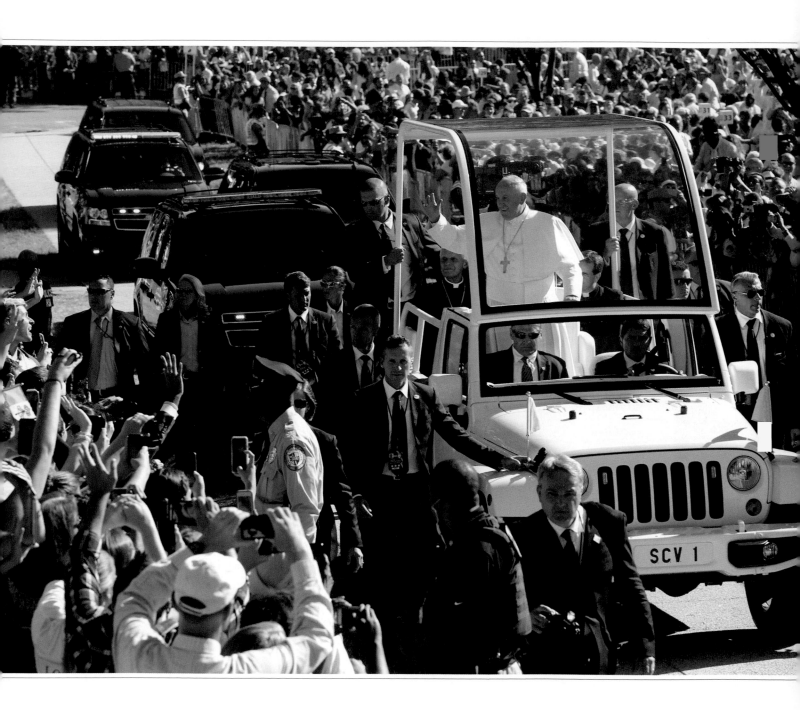

Introduction

POPE FRANCIS'S VISIT TO America September 19–27, 2015, was an event like no other. Although his initial invitation was to the World Meeting of Families, to be held in Philadelphia, the visit soon expanded.

Was it the coincidence with U.N. General Assembly meeting in New York City? Was it the breakthrough in U.S.-Cuba relations, brokered, in part, by Pope Francis himself? Or was it that this pope, an Argentine, in the third year of his pontificate, had never been in North America? Perhaps all of these.

Other invitations soon followed. He was invited to Congress by then-U.S. House of Representatives Speaker John Boehner, himself a Catholic. U.S. President Barack Obama had met with the pontiff at the Vatican in 2014, so there would be a reciprocal visit of the pope to the White House.

Then there was the opportunity to speak before the annual gathering of worldwide ambassadors at United Nations headquarters in New York City. Archbishop Charles Chaput's Philadelphia invitation had snowballed into a major international event.

Of course, it was all to be accented with Pope Francis's trademark apostolic witness of presence to the poor, with visits to an inner-city school in East Harlem, a Catholic Charities agency in Washington, D.C., a prison in Philadelphia. And there was the first-ever canonization on U.S. soil, of the Spanish-born Franciscan Junipero Serra.

Then came another surprise: Francis would make an apostolic visit to Cuba in the days before coming to the United States. America, after all, is more than the United States.

Pope Francis did not fail to surprise us further. From the gigabytes of fine photography and writing from Catholic News Service, from the pope himself speaking across many topics, we've tried to pick the most memorable moments.

"Love Is Our Mission" was the name the pope chose to call this pilgrimage. You'll see, in the photos and words that follow, that he challenges all of us to share that mission, to love, more deeply, the people and places of this earth. In this love we all will share the joy of the Gospel.

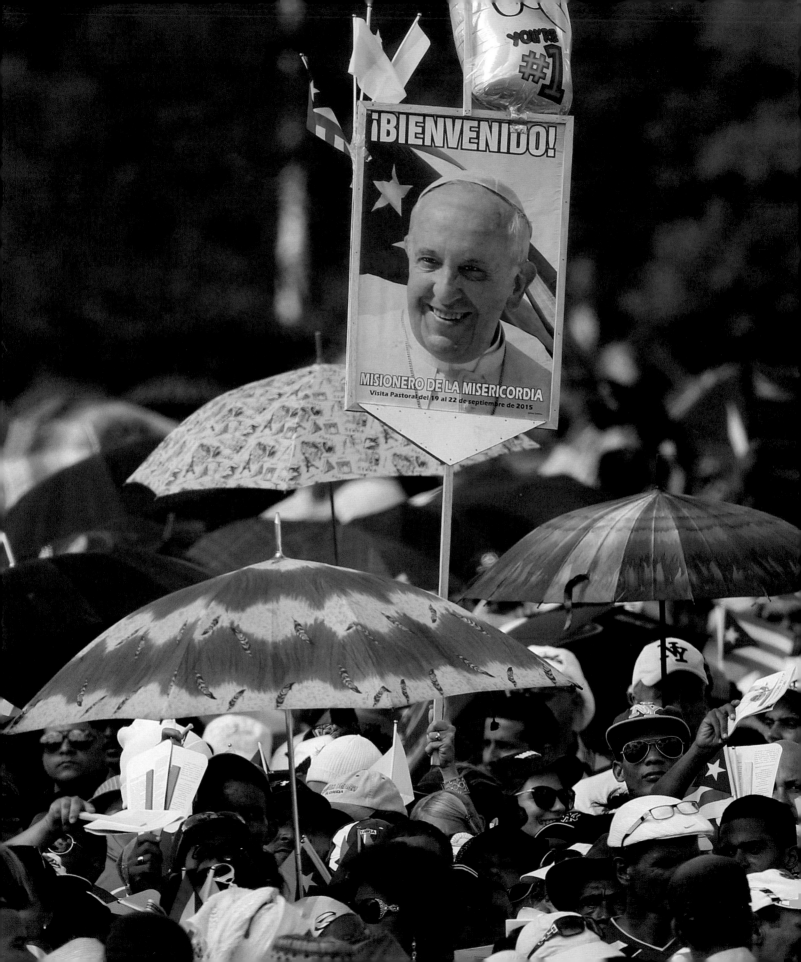

CUBA

"I will be among you as a missionary of mercy and tenderness." With that message to the Cuban people, Pope Francis set the tone for his apostolic voyage to America. He had been instrumental in a diplomatic breakthrough between Washington and Havana, and now, by adding Cuba to his U.S. visit, he would nudge us even closer. During three packed days, he celebrated Mass in Havana's Revolution Square, visited Holguin, and then traveled to Santiago de Cuba, where he made a pilgrimage to the nearby shrine of Our Lady of Charity of El Cobre, patroness of Cuba. "Hope is bold!" the pope told a gathering of young people in Havana. "Where do your hopes and aspirations lie?"

"All of us are called by virtue of our Christian vocation to that service which truly serves," Pope Francis tells two hundred thousand at Mass in Revolution Square.

The Holy Father's gentle blessing of a boy with a disability echoes a phrase from his homily at Mass in Havana: "We do not serve ideas, we serve people."

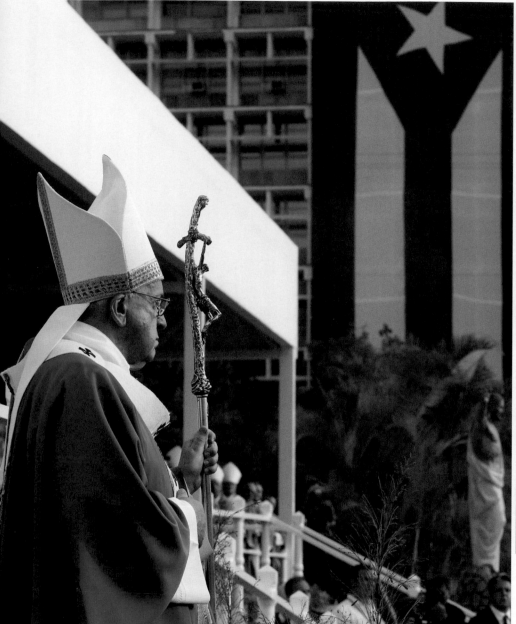

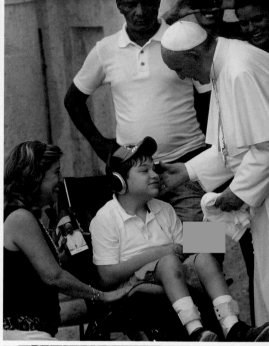

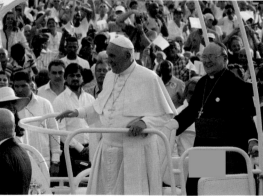

The abundance of radiant smiles in the Havana crowd reflects the pope's infectious joy, as he rides toward Revolution Square to celebrate Mass.

HAVANA, CUBA'S HEART
A SHEPHERD AMONG HIS SCATTERED PEOPLE

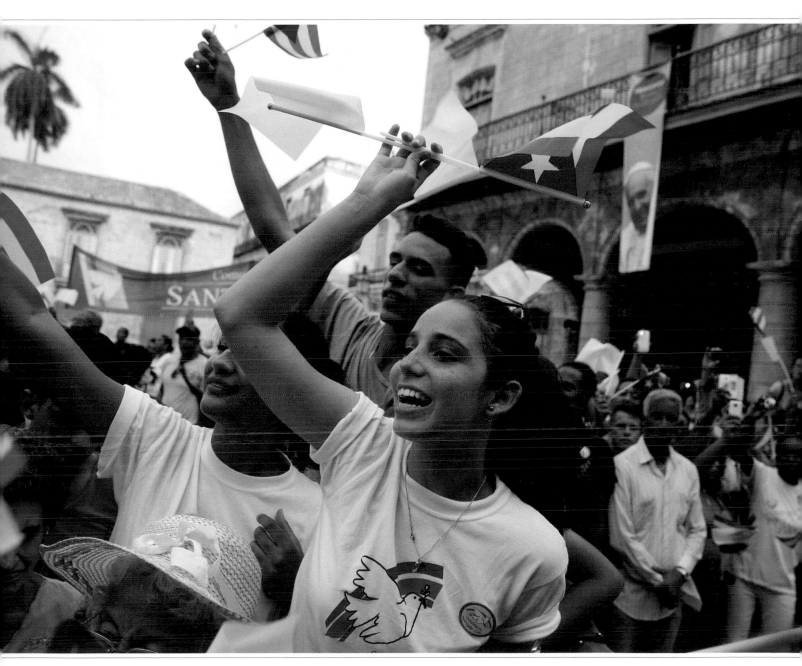

▲ The intense Havana heat does not deter this crowd from greeting Pope Francis as he arrives to celebrate evening prayer with priests, religious, and seminarians.

Pope Francis and the Cuban Thaw

POPE FRANCIS'S THREE-DAY apostolic visit to Cuba preceded his U.S. visit and came on the heels of a historic warming of relations between the two nations. The pope played a pivotal role in what is popularly referred to as the Cuban Thaw, resulting in the normalization of diplomacy and a reinvigorated hope that economic ties may soon be restored.

According to a Vatican statement, the Holy Father sent letters to both U.S. President Barack Obama and Cuban President Raúl Castro, calling on them "to resolve humanitarian questions of common interest, including the situation of certain prisoners, in order to initiate a new phase in relations."

Thanks in part to the pope's efforts, a prisoner exchange took place in December 2014. Delegations from the United States and Cuba also met quietly at the Vatican, where both parties came to crucial agreements regarding diplomacy.

A 2009 report from the U.S. Chamber of Commerce estimates the embargo against Cuba annually costs the United States $1.2 billion in lost sales of exported goods. The Cuban government estimates Cuba's own annual losses to be $685 million. Beyond the economic damage, the human costs include subpar access to medicine, food, and clean water on the island, as well as the painful separation of families between Cuba and the United States.

In a December 17, 2014, address to the nation,

President Obama announced that a new era of diplomacy with Cuba would begin, and thanked the pontiff for his role. "In particular, I want to thank His Holiness Pope Francis, whose moral example shows us the importance of pursuing the world as it should be, rather than simply settling for the world as it is," the president said.

President Castro, too, expressed his gratitude to Pope Francis, after visiting the Vatican in May 2015. "I am very happy. I have come here to thank him for what he has done to begin solving the problems of the United States and Cuba," Mr. Castro said. "If the pope continues this way, I will go back to praying and go back to the Church. I'm not joking."

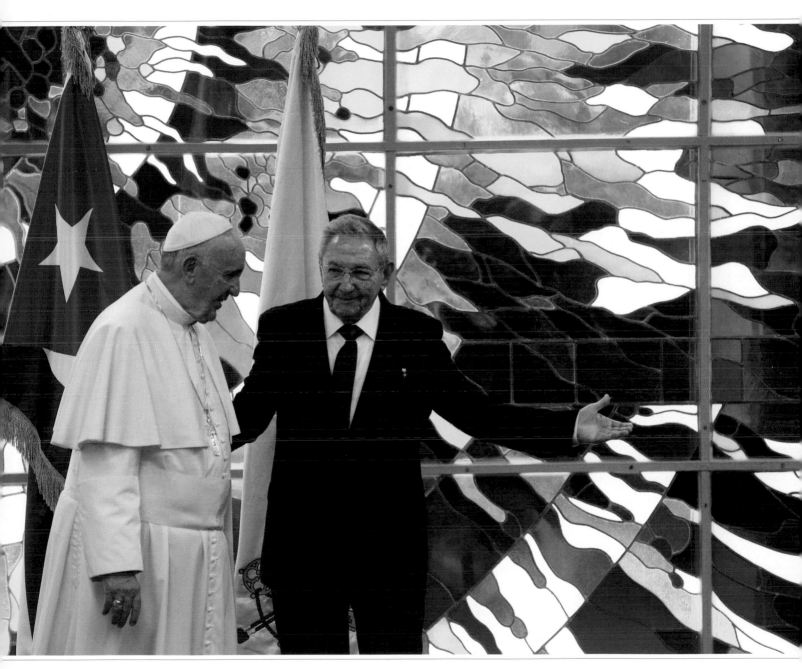

Ʌ The pope meets with President Raúl Castro in the Museum of the Revolution, calling for greater religious freedom for the nation's Catholics.

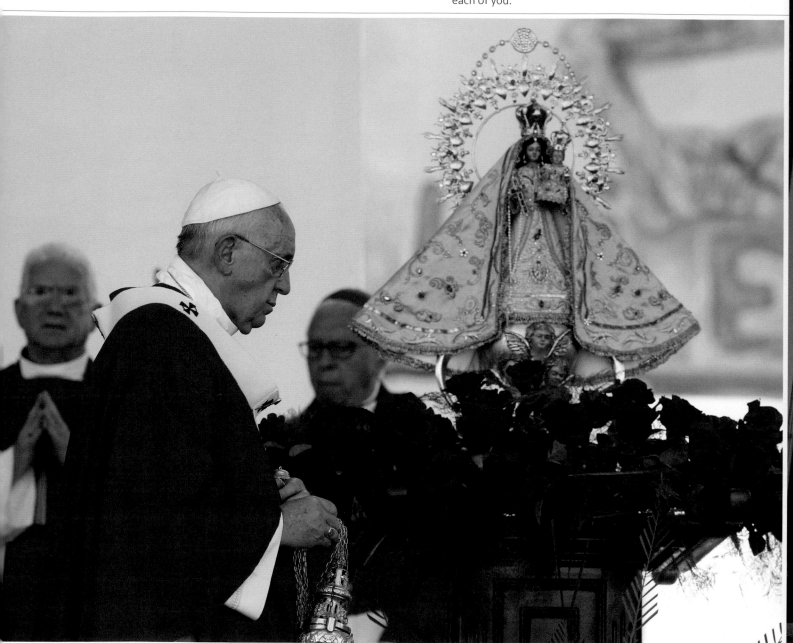

▼ Pope Francis, blessing a replica statue of Our Lady of Charity of El Cobre in Holguin, asks that "her eyes of mercy ever keep watch over each of you."

EAST ACROSS THE ISLAND
HOLGUIN, SANTIAGO DE CUBA, AND EL COBRE

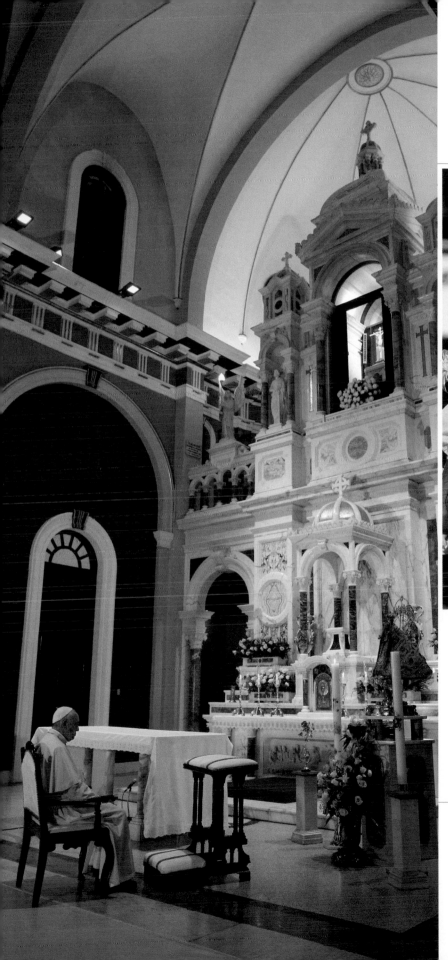

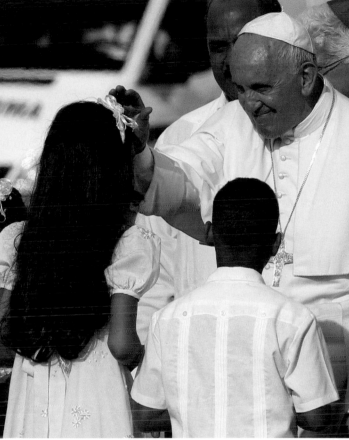

▲ Children accept a blessing and offer a warm welcome to the pope in Santiago de Cuba, one of three cities on the apostolic visit to the Caribbean nation.

◄ In a quiet moment, Pope Francis prays before the original statue of Our Lady of Charity of El Cobre. Believed to be miraculous, it dates to the 1600s.

The Church and Cuba

POPE JOHN PAUL II MADE A breakthrough visit to Cuba in 1998, the first pope to visit that nation since popes started traveling widely in the 1960s, the decade after Cuba's revolution. The Church in Cuba has been repressed to various degrees since the revolution. Church properties were nationalized, including a broad network of Catholic schools, a life-blood of Church membership. Many priests, religious, and leading Catholics emigrated or were exiled.

Most remaining Catholics were kept at arm's length from the Church. Atheism was mandated for years. Even as bans have loosened over the decades, government resistance remains, and participation in the Church has declined. About 60 percent of Cubans are baptized Catholics.

During his apostolic visit, Pope John Paul II had set loose the streams of religious longing that had marked the hearts of many Cubans. At a poignant moment in 1998, on national television, he placed a crown on the statue of Our Lady of Charity of El Cobre.

That statue has been a symbol of devotion, nationally, across faiths, for over four hundred years since it was discovered in a bay by two indigenous sailors and a slave. John Paul II's dramatic visit to the shrine as well as Pope Francis's are signs that the Catholic Church is anything but dead in Cuba.

Significant challenges remain, though, in the efforts of the Church to find a proper footing in Cuba. There is widespread distrust

of any dealings with the Castro government on the part of the Cuban émigrés. Says Eduardo Azcarate, a Cuban expatriate living in Falls Church, Virginia, "There has to be reconciliation, and there has to be giving up of old concerns, of old doubts, old fears, old hurts that have accosted us."

The pope is working to heal those divisions. "Our revolution comes about through tenderness," said Pope Francis, in Havana, "through the joy which always becomes closeness and compassion, and leads us to get involved in and to serve the life of others."

The Church, he added, wants to be with the Cuban people "to build bridges, to break down walls, to sow seeds of reconciliation."

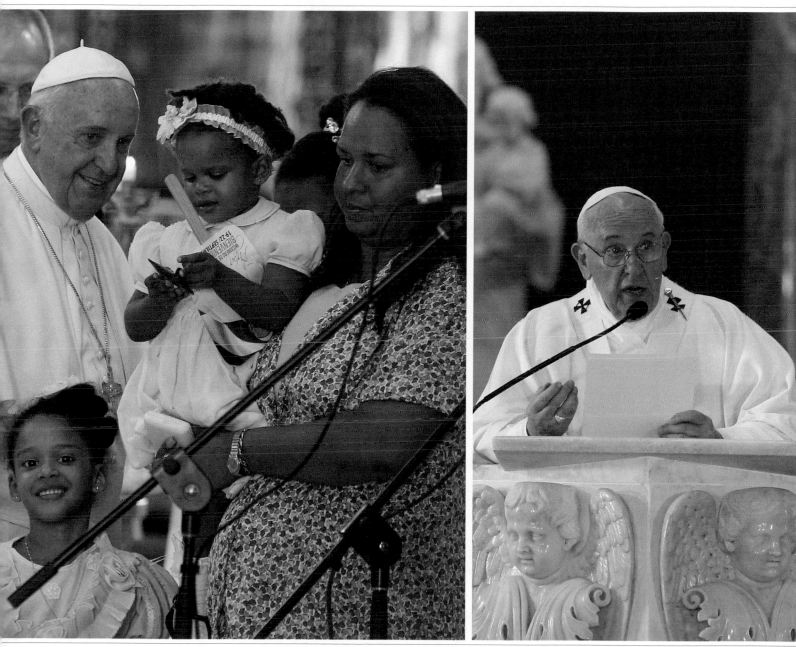

"The family is the greatest treasure of any country," Pope Francis says. Here he encounters a woman and her two children in the Cathedral of Our Lady of the Assumption in Santiago de Cuba.

At the Shrine of Our Lady of Charity of El Cobre, the pope challenges those in attendance—and all of Cuba—to start a "revolution of tenderness."

"Thank you, Cubans, for making me feel part of a family, for making me feel at home."

—POPE FRANCIS, MEETING WITH FAMILIES IN SANTIAGO DE CUBA

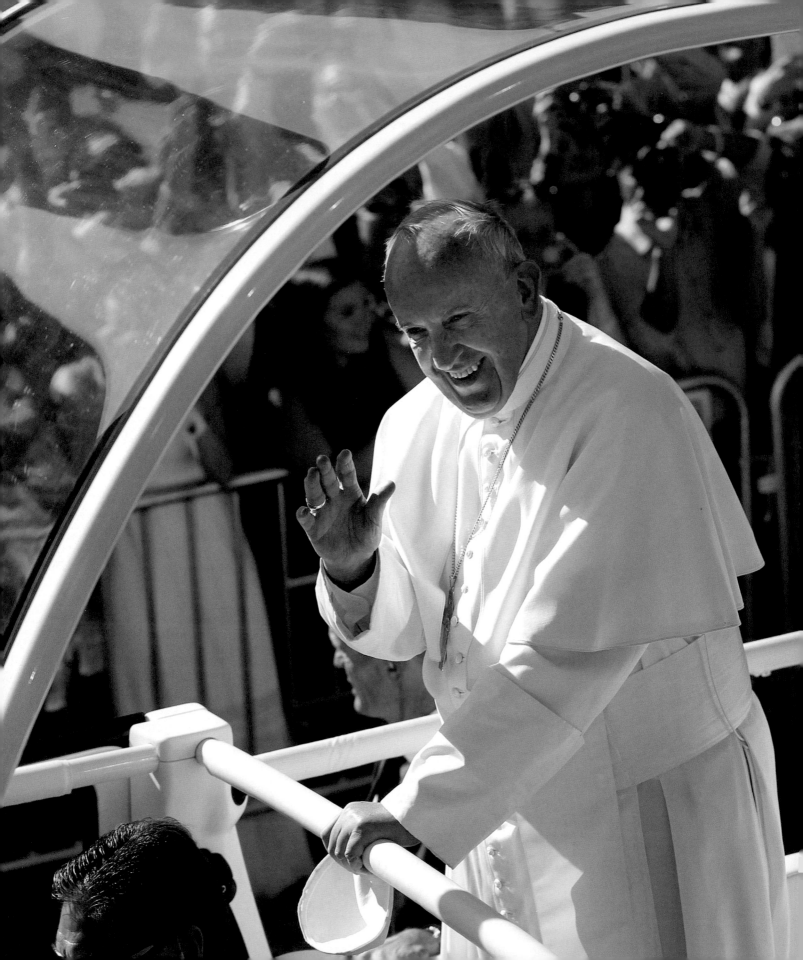

WASHINGTON, D.C.

Considering he was in our nation's capital for only two days, Pope Francis certainly covered a lot of ground. He met with President Barack Obama and gave a speech to eleven thousand people on the White House lawn, led a prayer service for U.S. bishops, canonized Junipero Serra in front of twenty-five thousand congregants, had a brief visit with homeless people at a Catholic Charities program, and spoke to a joint meeting of Congress. There he offered the example of four Americans as guideposts for civic engagement. At the White House, he set forth several urgent challenges around the environment and society. His visit to our nation's capital was an encouragement to all Americans: Listen, pray, and act, in service of the common good.

▼ President Barack Obama and his family go to Joint Base Andrews, in a rare on-the-spot welcome for a foreign dignitary.

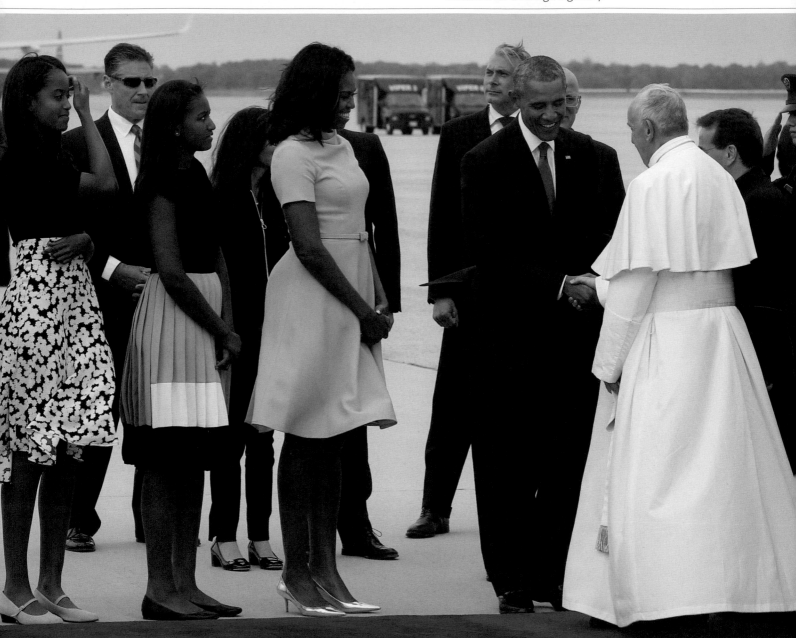

OUR NATION'S CAPITAL
POPE, PRESIDENT, PRELATES, PEOPLE—AND CONGRESS

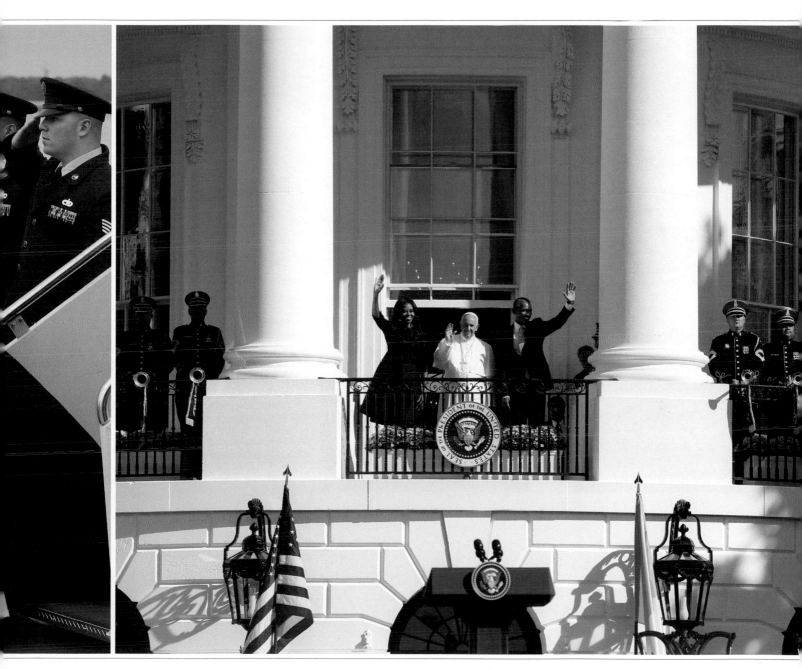

⌃ The Obamas present their guest from
the south portico at the White House as
thousands are on hand to witness this
historic moment.

⅄ President Obama calls the pope a living reminder of our common goal to care for the world and those who share it, saying, "You are shaking us out of complacency."

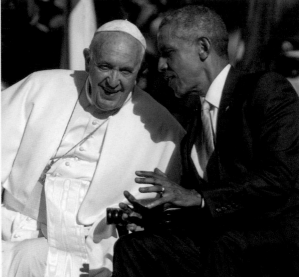

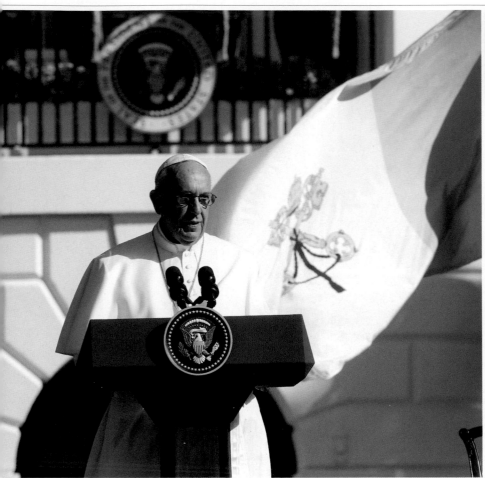

⅄ With his first address to the American people, the Holy Father dives into the political fray by speaking on climate change, marriage, and immigration.

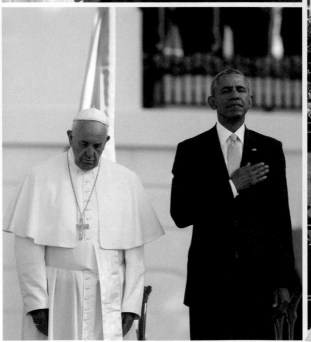

⅄ Though solemn during the National Anthem, the pope enthusiastically praises this country's commitment to "building a society which is truly tolerant and inclusive."

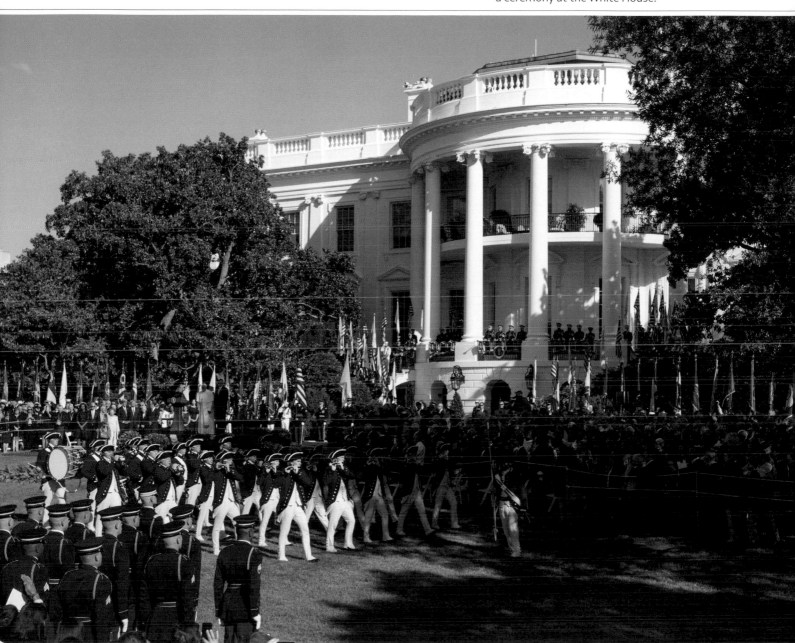

"Climate change is a problem that can no longer be left to future generations."

—POPE FRANCIS AT THE WHITE HOUSE

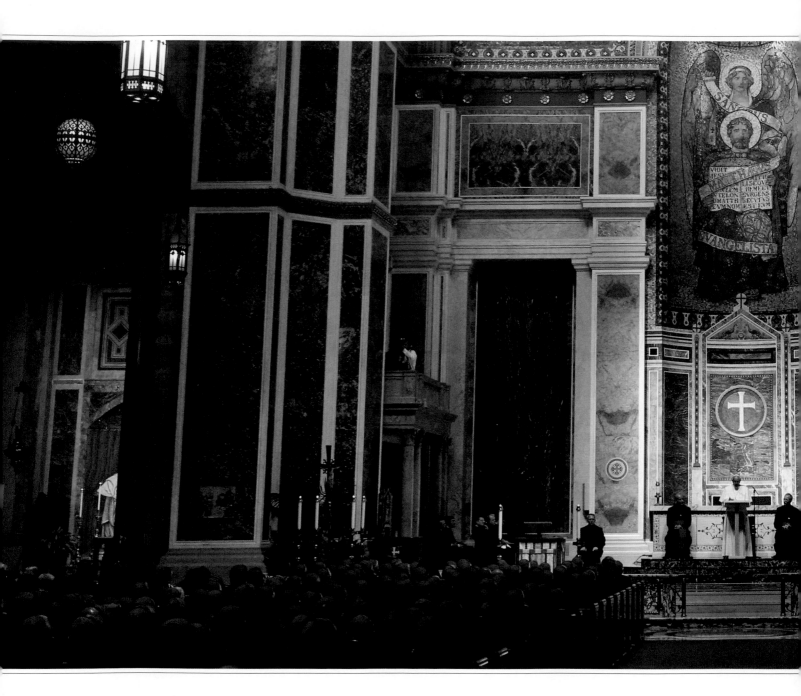

WORDS TO OUR BISHOPS
"FACE THE CHALLENGES OF THE DAY"

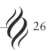

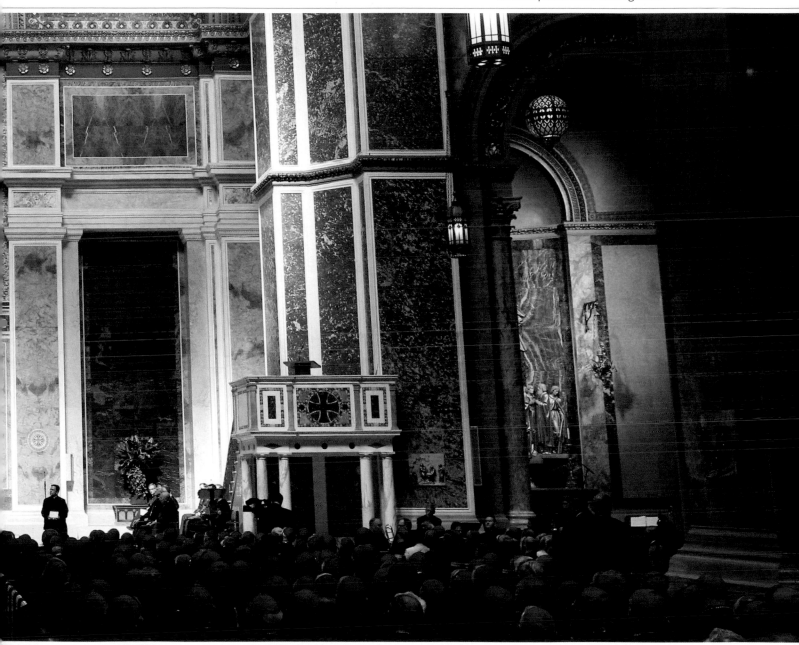

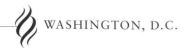

Pope Francis @Pontifex

Let the Church always be a place of mercy and hope, where everyone is welcomed, loved and forgiven.

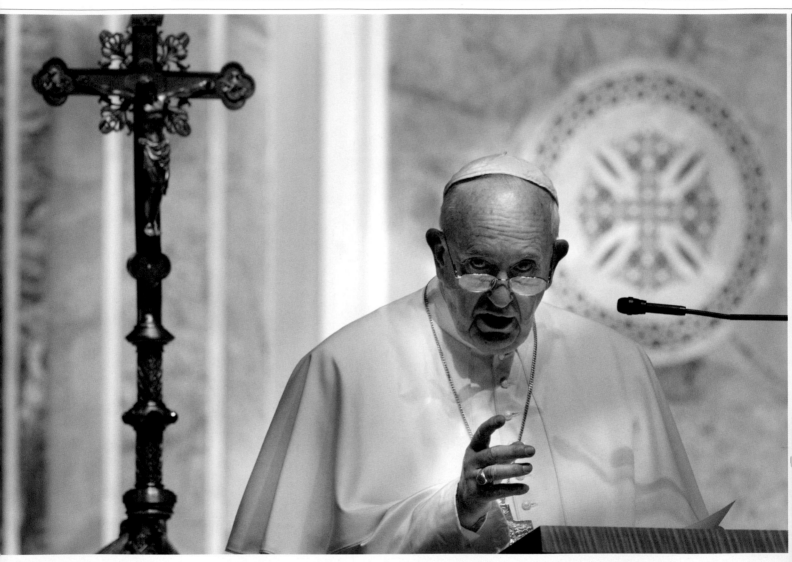

"The life of a pastor is not about preaching complicated doctrines, but joyfully proclaiming Christ who died and rose for our sake," says the pope.

The bishops enthusiastically welcome Pope Francis. It is a first-time meeting with the pope for many of them.

The pope jokes with local host Cardinal Donald Wuerl, archbishop of Washington, D.C. Master of Ceremonies Msgr. Guido Marini looks on.

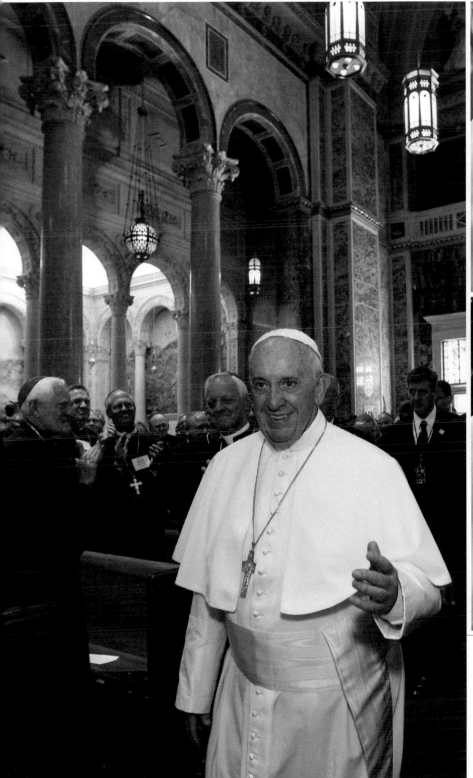

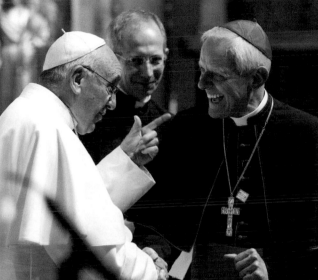

Pope Francis greets Cardinal Seán O'Malley of Boston, a Franciscan and a member of the council of nine cardinals advising the pope about reforming the Church's governance.

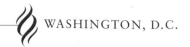

This statue of Junipero Serra is one of one hundred (two from each state) in the U.S. Capitol's Statuary Hall. The State of California presented it in 1931.

ST. JUNIPERO SERRA
A FIRST FOR THE UNITED STATES

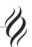

Pope Francis greets seminarians, men and women religious, and their families inside the Basilica of the National Shrine of the Immaculate Conception.

A Friar of His Times

JUNIPERO SERRA (1713–1784) was born on the Mediterranean island of Mallorca. He became a Franciscan friar, then a priest, and a well-respected teacher of philosophy. In 1750, he was drawn to the stories coming back across the Atlantic from Franciscan missionaries. He was assigned to Mexico.

In 1769, he was named *presidente* of the missions to be established in Alta California (now the state of California). Mission San Diego (1769) was followed by eight others under Serra's leadership—and another twelve after his death at Mission San Carlos in Carmel, where he is buried. He was beatified in 1988.

Because Serra experienced numerous conflicts with military commanders, he once traveled to Mexico City and gained from the viceroy greater legal protection for California's Native Americans. That protection weakened after Mexican independence (1821) and disappeared in 1834.

Andrew Galvan, a modern Ohlone Indian and curator of Mission Dolores in San Francisco, speaks openly about colonization's negative effects. He notes that the newly introduced horses, cows, pigs, goats, and lambs ate the native grasses, destroying animal habitat.

He continues: "As their way of life became increasingly threatened, the native peoples saw how the missions were developing. They saw the corn in the fields, the cattle that would be slaughtered. They reached a time of little choice. Every tribal group comes to this moment. They moved to the missions for survival.

"The anthropologists tell us the California native was probably the cleanest person in the world. We were living in unison with nature. In the missions, people were densely crowded, religion and language were changed, and in unsanitary and unhealthy conditions, they're going to get sick. It was a disastrous choice."

Although some Native Americans object, Galvan supports Serra's canonization because of the new saint's respect for the people he sought to bring to Christ. When Mission San Diego was burned in 1775 and one friar was murdered, Junipero prevailed on the comandante that the local people responsible not be executed.

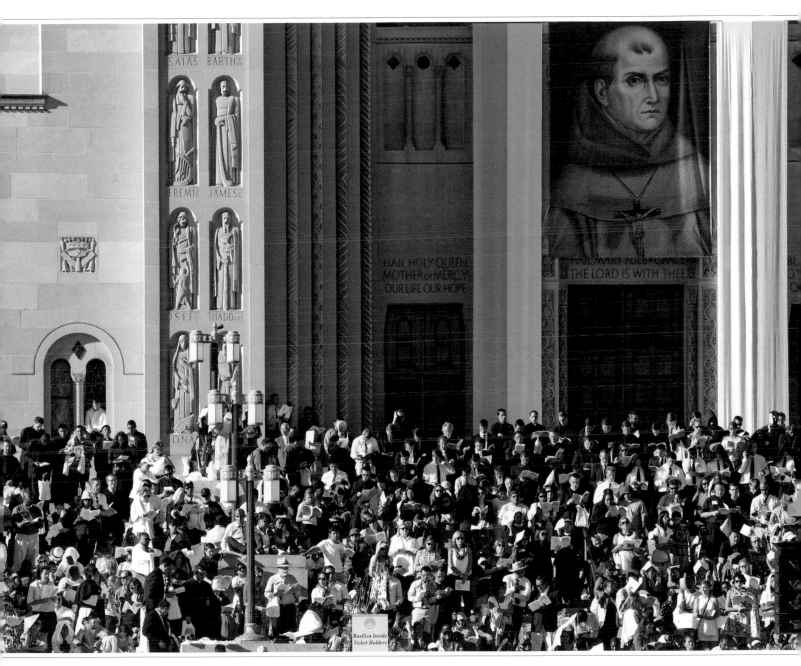

Crowds wait beneath a banner over the shrine's main entrance. This portrait reproduces a painting made soon after Junipero's death.

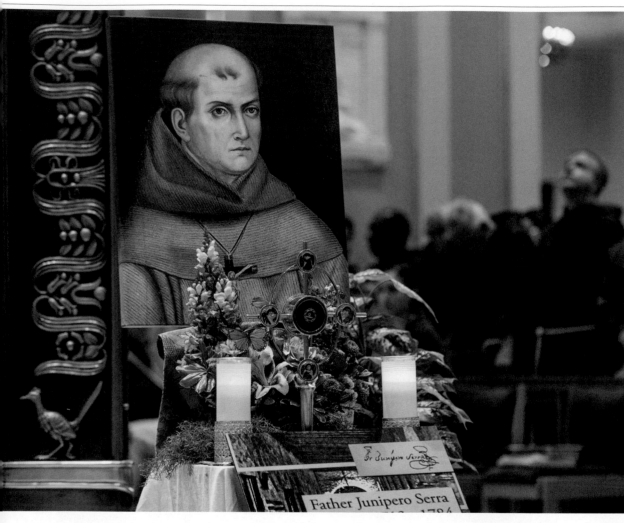

St. Junipero's image and a relic were part of a Mass of thanksgiving at the Franciscan Monastery of the Holy Land in Washington, D.C.

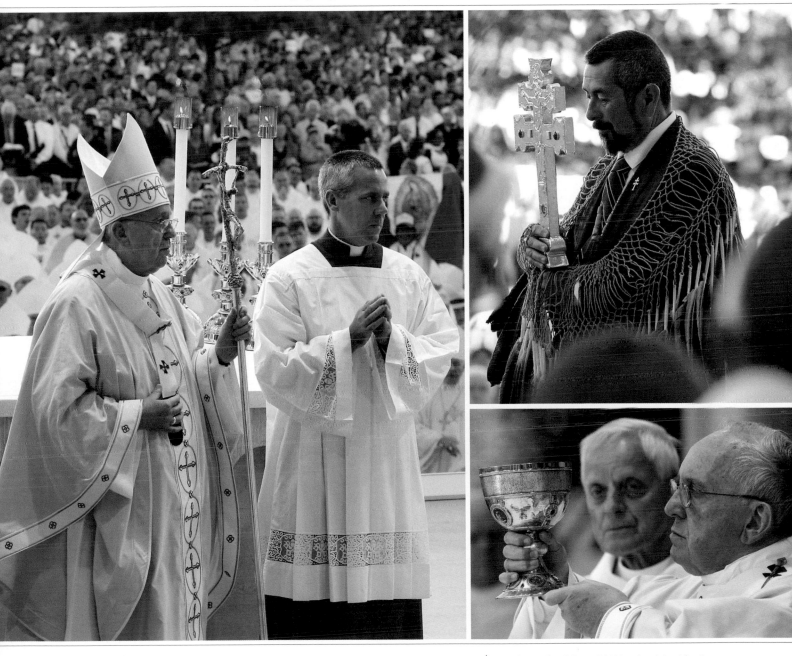

▾ During the canonization Mass, Pope Francis preaches that the joy of the Gospel can be "known and lived only through giving ourselves away."

▾ Andrew Galvan, a member of California's Ohlone people, brings forth relics of St. Junipero at the canonization Mass.

▲ With Cardinal Donald Wuerl at his side, Pope Francis raises a chalice during the canonization Mass at the National Shrine.

The Holy Father shoos away guards and welcomes a determined Sophie Cruz, who has a heartfelt plea: Help immigrant parents illegally living in the United States.

AMONG THE FAITHFUL
A SUNNY DAY ON THE STREETS OF WASHINGTON

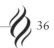

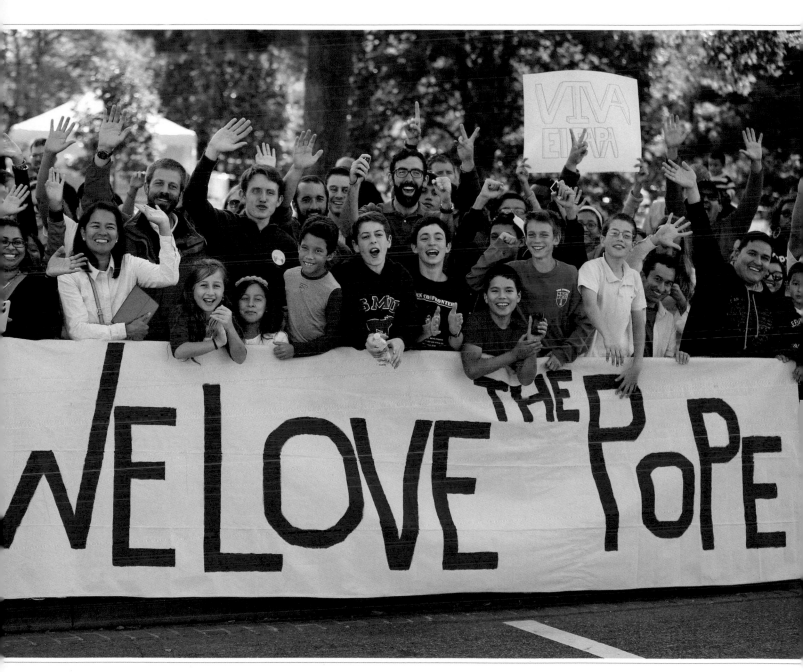

WE LOVE THE POPE

VIVA EL PAPA

Fans eagerly await Pope Francis along the parade route. "It's cool that people come together out of respect for this religious leader," says an impressed observer.

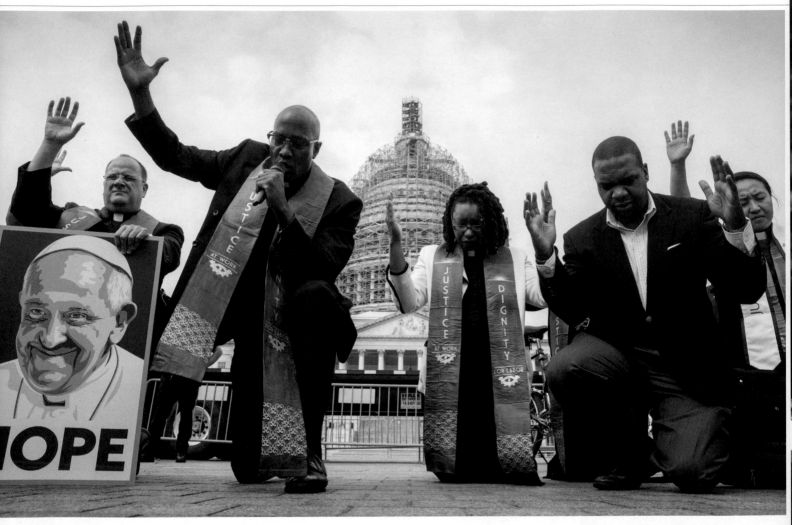

⋀ Faith leaders pray in front of the U.S. Capitol for low-wage workers, bringing into the public eye an issue of social justice that goes far beyond Washington.

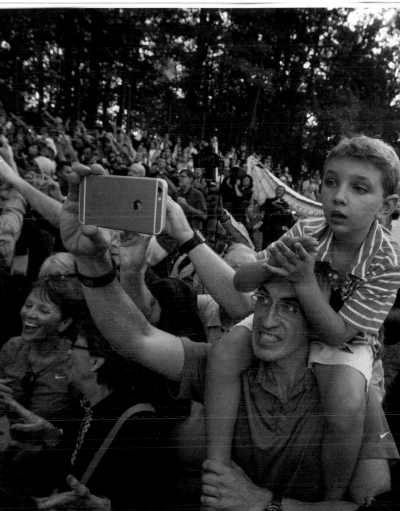

◄ In spite of the hot day, thousands of enthusiastic onlookers line up to greet Francis as he is paraded in the popemobile.

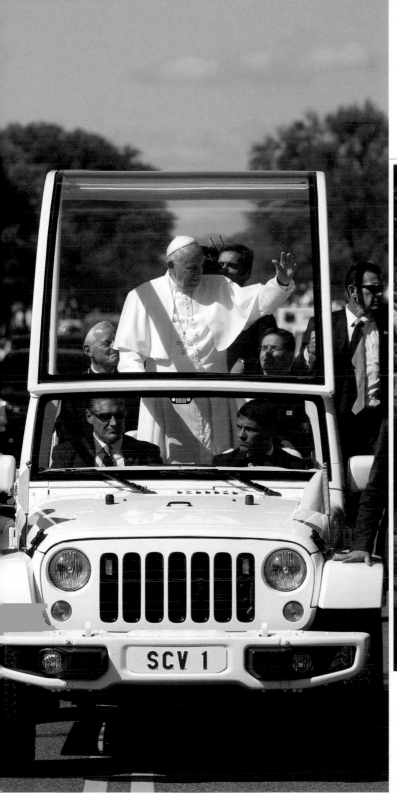

▲ Washington, D.C., residents Dan Turrentine and his son, Davis, wait in anticipation— smart phone in hand—for the pope to arrive at the Vatican embassy.

Pope Francis @Pontifex

Let us ask the Lord for this grace: that our hearts become free and filled with light, so that we can rejoice as children of God.

Flanked by congressional and Church leaders, Pope Francis greets attendees on the Capitol lawn.

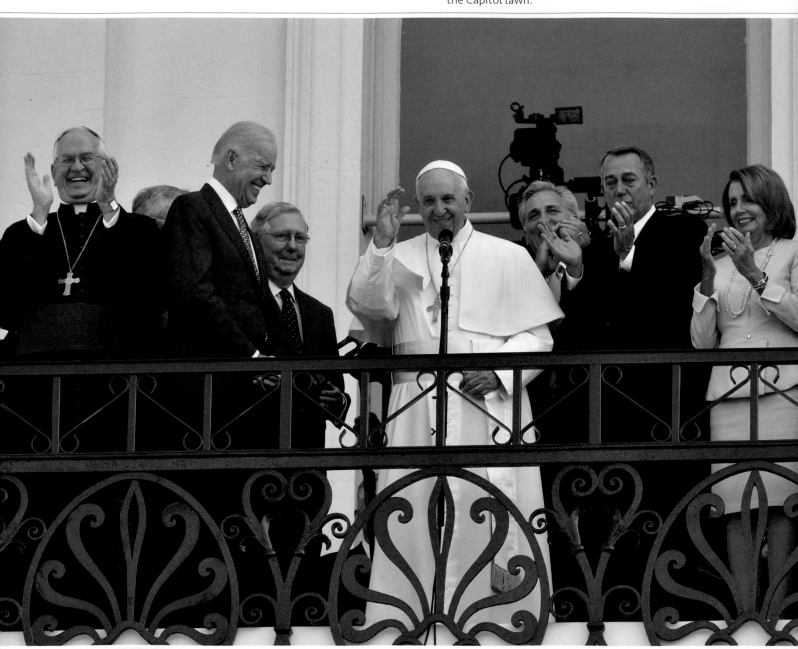

JOINT MEETING OF CONGRESS
SENATE AND HOUSE RECEIVE HIS HOLINESS

He applauded us for being the "land of the free and the home of the brave," but Pope Francis came to Congress with challenges. He pleaded that we welcome those "who have traveled north," noting that most American families once immigrated. But he also talked about life issues and implored us to be bold enough to embrace change. He compellingly offered Americans Abraham Lincoln, the Rev. Martin Luther King Jr., Dorothy Day, and Thomas Merton as inspiring examples.

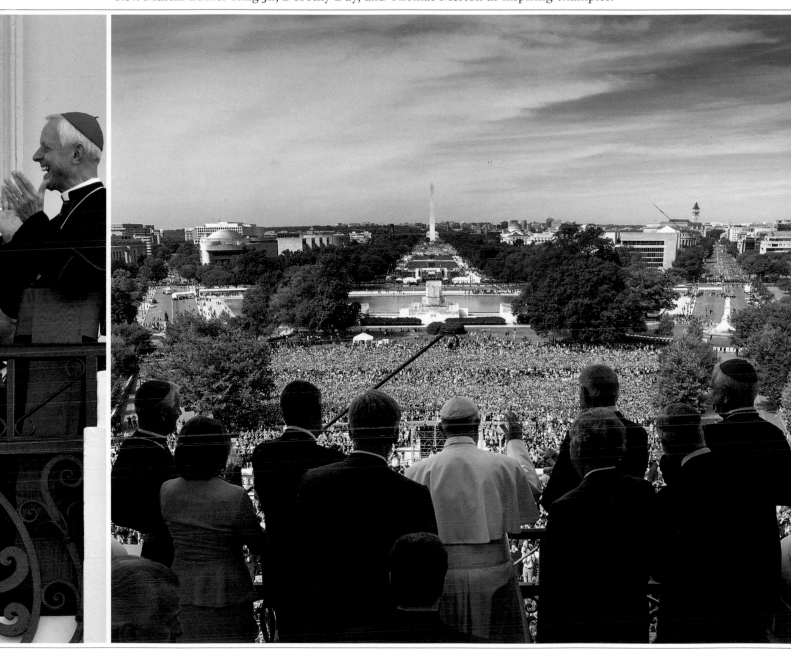

⋏ Pope Francis proclaims, "God bless America!" at the end of his blessing for people who had watched his congressional talk via jumbotron.

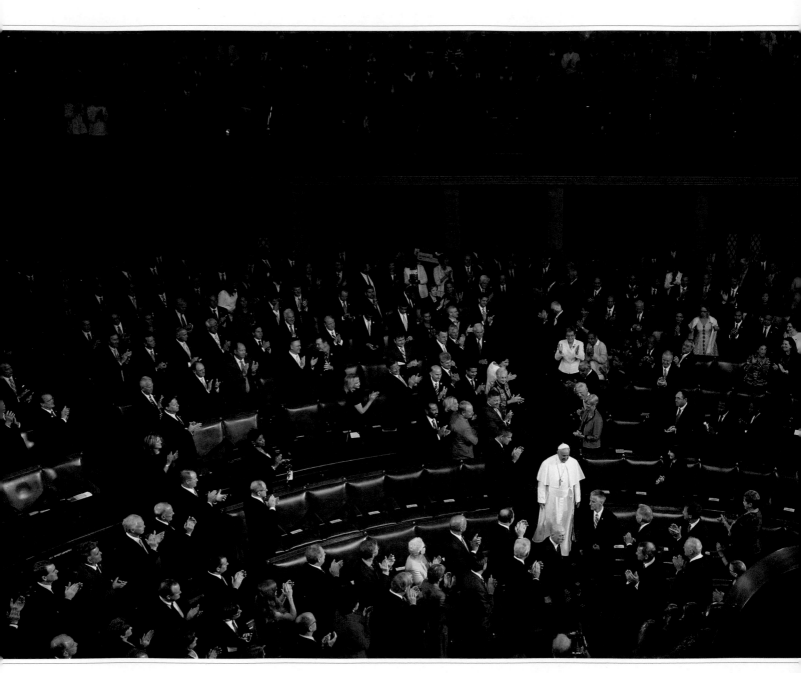

Pope Francis enters the House of Representatives chamber to address a joint meeting of Congress at the U.S. Capitol.

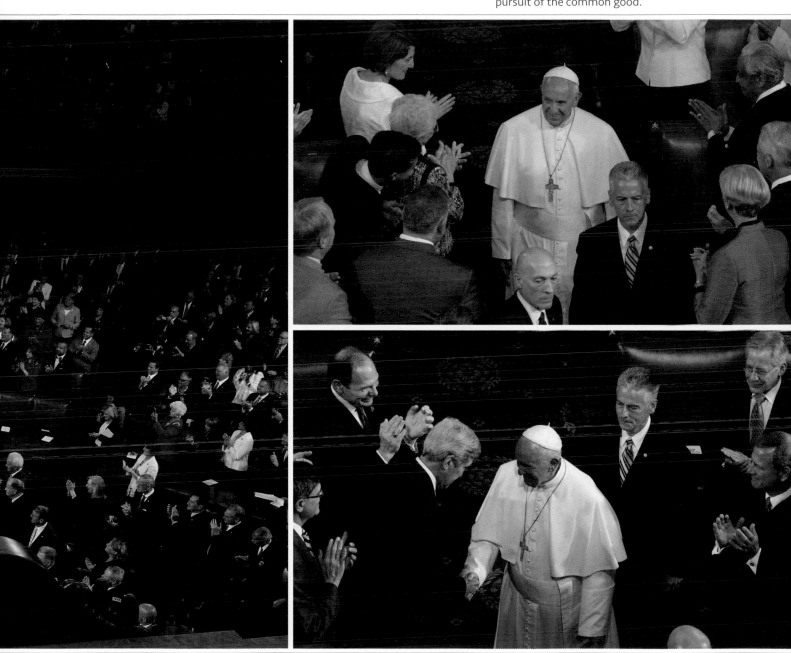

▼ Pope Francis will praise members of Congress for engaging in "the demanding pursuit of the common good."

▲ Pope Francis shakes hands with U.S. Secretary of State John Kerry as U.S. Chief Justice John Roberts (right) looks on. Both are Catholic.

▼ The pope warns against a simple reduction-
ism that sees only good or evil, the righteous
and the sinners.

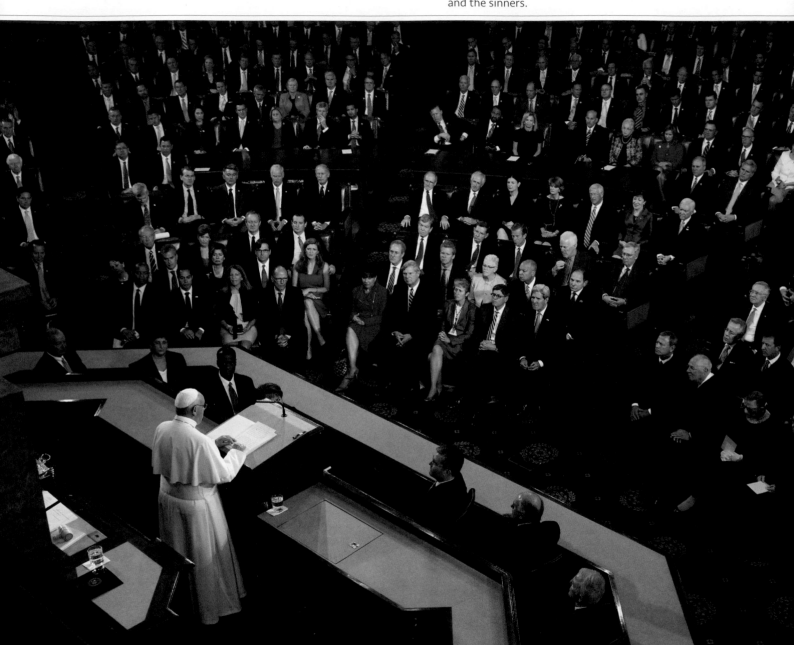

"Our efforts must aim at restoring hope...
promoting the well-being of individuals and of peoples."

—POPE FRANCIS AT THE UNITED STATES CONGRESS

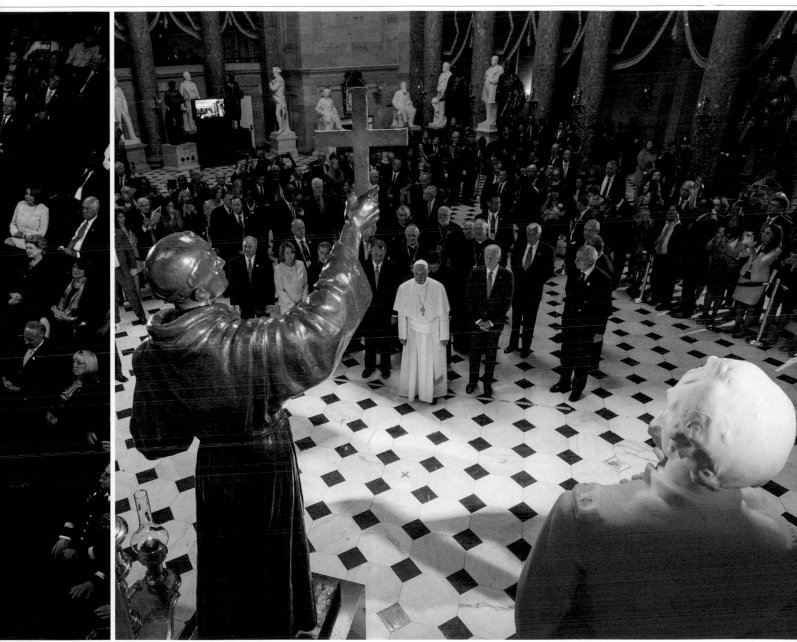

▼ Pope Francis, surrounded by members of Congress, pauses before a sculpture of the Church's newest saint, Junipero Serra.

▼ Parishioners of St. Patrick in the City Church were selected from a lottery to visit with Pope Francis (pastor Msgr. Salvatore Criscuolo is seen waving).

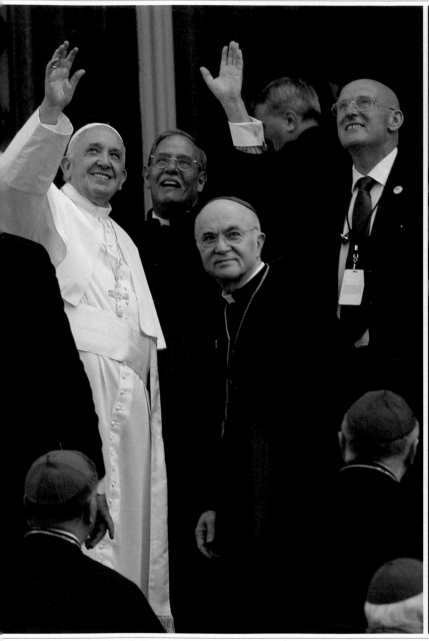

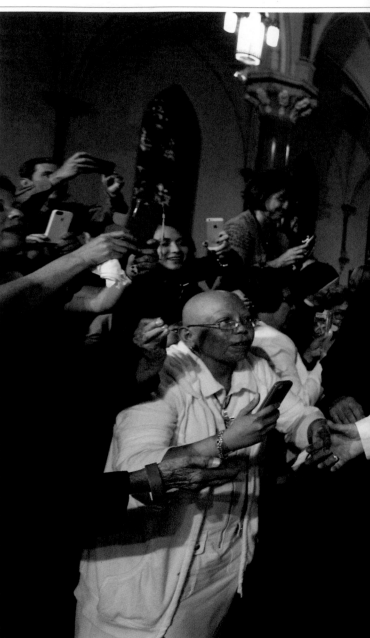

FEED THE HUNGRY
PERSONAL ENCOUNTER IS THE POPE'S MESSAGE

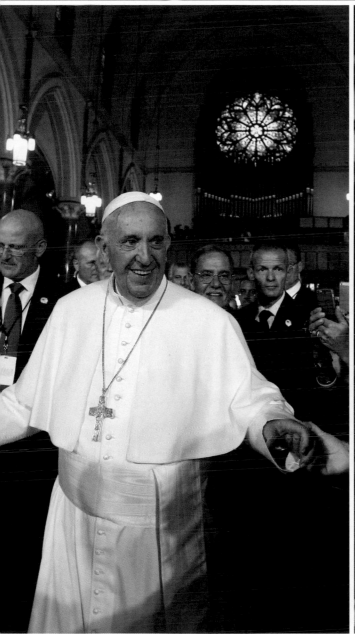

Pope Francis greets parishioners of St. Patrick before his talk. "We can find no social or moral justification, no justification whatsoever, for lack of housing," he says.

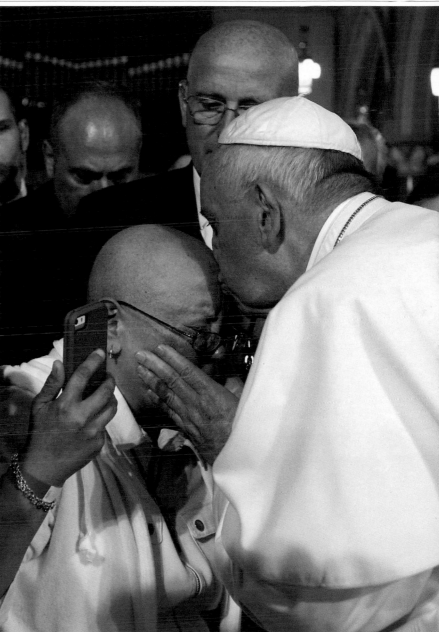

Though his Washington, D.C., itinerary is locked solid, that doesn't stop the people's pontiff from veering off script to kiss a woman's forehead.

Serving Those in Need

JESUS CALLED HIS DISCIPLES to feed the hungry, welcome the stranger, clothe the naked, minister to the sick, and visit the imprisoned. Since its founding in 1910, Catholic Charities USA has been living out that Gospel mandate by organizing and carrying out corporal works of mercy. Agencies across the country engage the faithful to respond to their baptismal call: to love and serve those in need.

Once known as the National Conference of Catholic Charities, the organization was founded "to bring about a sense of solidarity" among those working in charitable ministries and to be "an attorney for the poor."

The national organization currently provides assistance to 164 member agencies in 2,631 locations throughout all fifty states and many U.S. territories. Those agencies help the homeless, hungry, sick, and vulnerable in their communities, regardless of religious affiliation.

Catholic Charities USA also coordinates national disaster relief and impact-reduction strategies, as well as advocating for justice in government and other social structures.

Its antipoverty efforts are especially needed as American society is marked by a greater disparity between haves and have-nots and a shrinking middle class. Recent government statistics show that nearly one in five U.S. citizens lives in poverty. One out of every ten people older than sixty-five is in poverty; one in five people in poverty is a child. All told, the government estimates that there are forty-eight million living in poverty in the United States. That, of course, does not include undocumented persons, a steady stream of whom Catholic Charities agencies serve. The percentage of U.S. citizens living in poverty is the highest it has been in nearly fifty years.

In a message to Catholic Charities workers in 2014, Pope Francis said they were "the very hands of Jesus in the world." The pope visits places such as prisons, shelters, and St. Maria's Meals, pictured here, to model his theology of encounter. That's his belief that being face-to-face with people in need allows for not only a handout, but for a one-to-one relationship— the heart of Christianity.

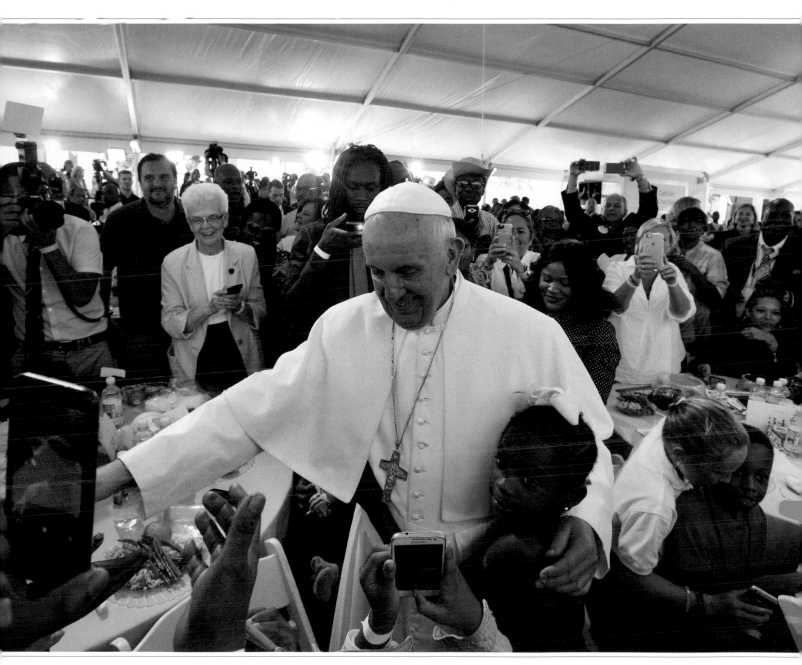

▲ While visiting St. Maria's Meals program at St. Patrick, the pope reminds us that Jesus identifies "with all those who suffer, who weep, who suffer any kind of injustice."

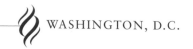
▼ Spending time with the volunteers and clients at St. Maria's Meals means declining an invitation to dine with politicians.

⋀ Waiting for the arrival of Pope Francis, Kaydn Dorsey and Lionel Perkins let their creativity shine with their crayons and pictures of His Holiness.

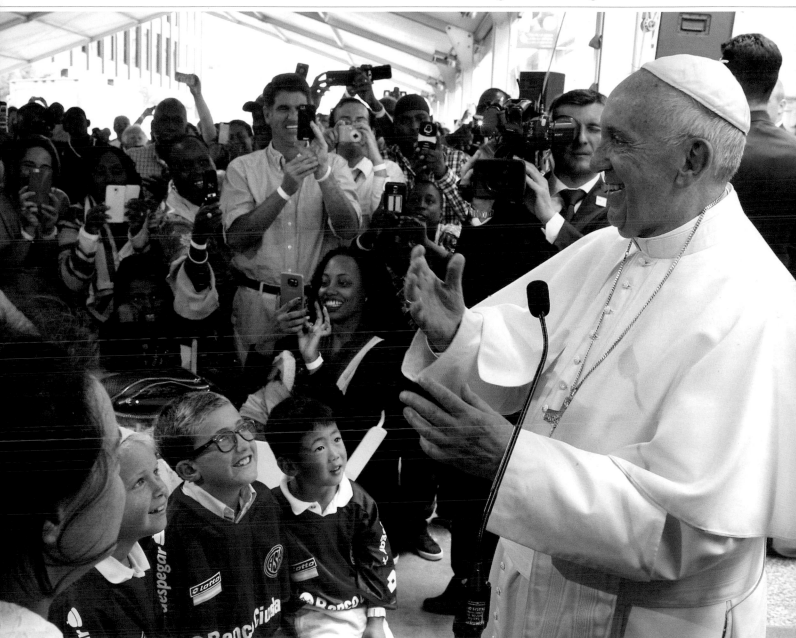

Francis reminds us of our Gospel mission: "[Jesus] tells us this clearly, 'I was hungry and you gave me food, I was thirsty and you gave me something to drink.'"

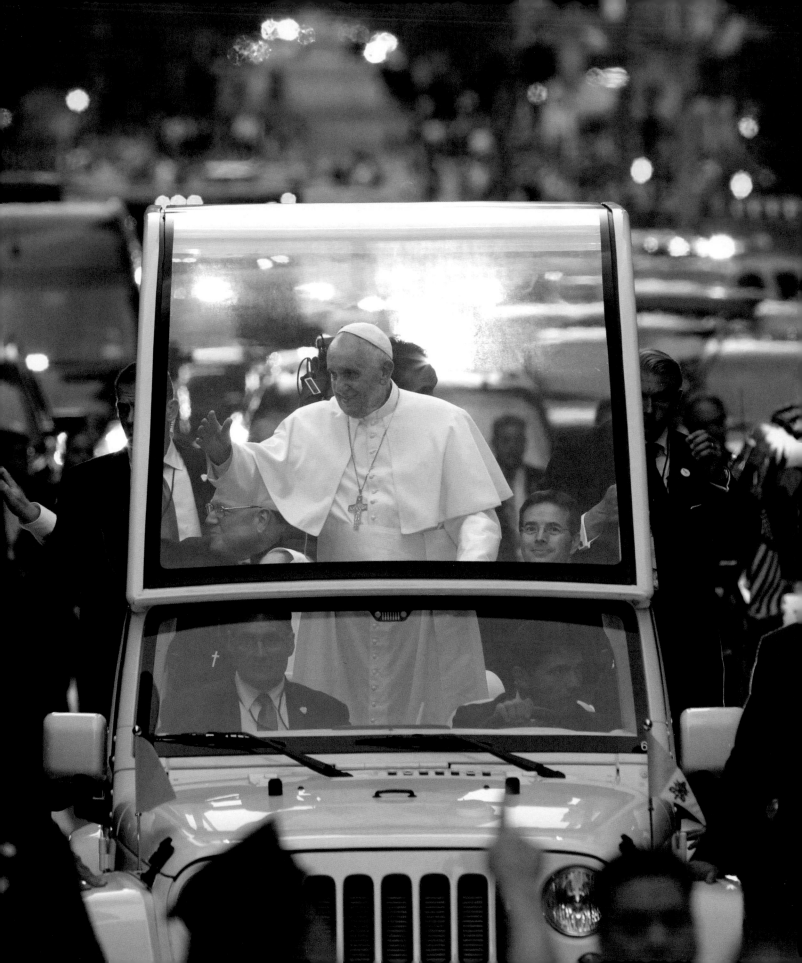

NEW YORK

From the moment he stepped off the Marine Corps helicopter and into his humble four-door Fiat 500L, Pope Francis was living the fast-paced life of a New Yorker. One could only wonder how he looked so relaxed, so energized while keeping such a tough schedule. He met with priests and bishops, addressed the United Nations, visited an inner-city school, prayed with leaders of all faiths amid the ruins of the World Trade Center, and greeted onlookers, the curious and the faithful, along the way—not bad for a seventy-eight-year-old who's been traveling internationally giving speeches for the past week! He capped it off with a beautiful Mass, including a profound homily, in the heart of Manhattan at Madison Square Garden.

▼ Cell phones and cameras are ready as
Pope Francis approaches on Fifth Avenue.
Throughout the visit, onlookers waited
hours for a glimpse of the Holy Father.

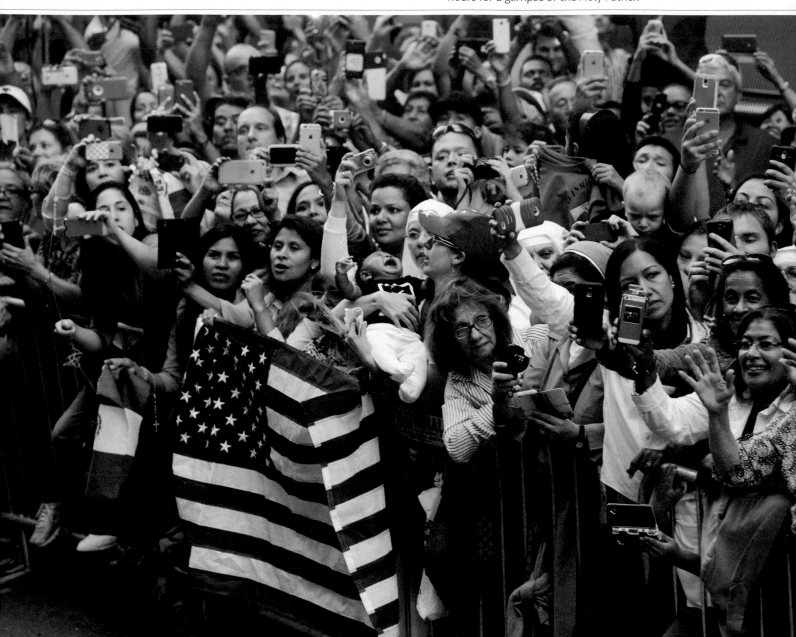

AN OUTPOURING OF LOVE
POPE FRANCIS ENCOUNTERS NEW YORK CULTURES

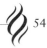

▼ Pope Francis is a shepherd among his flock as he is greeted by thousands of the faithful during his drive through Central Park.

⅄ A student greets the Holy Father and receives an informal papal blessing at John F. Kennedy International Airport.

⅄ A member of the Sisters Adorers of the Precious Blood presents the pope with a bouquet of flowers before his departure to the World Meeting of Families.

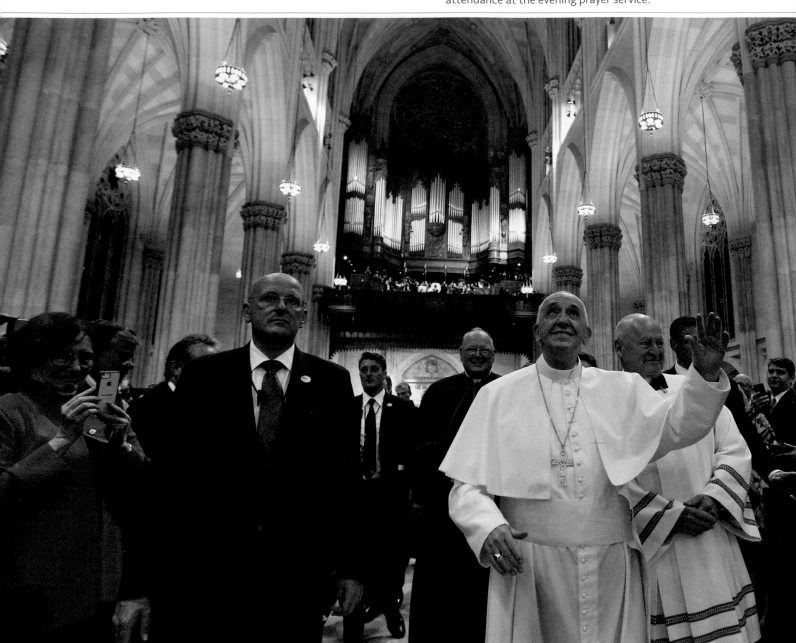

▼ With a warm smile that has become his signature, Pope Francis greets those in attendance at the evening prayer service.

ST. PATRICK'S CATHEDRAL
"JOY SPRINGS FROM A GRATEFUL HEART"

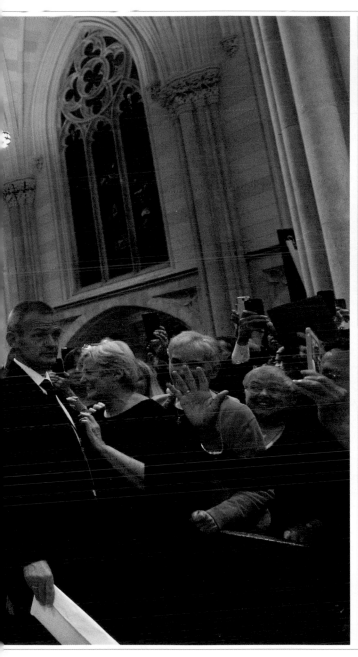

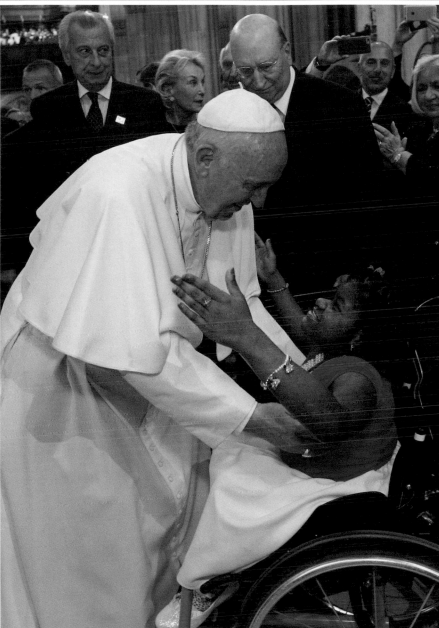

> ⋏ This pope reminds us to reach beyond the familiar, as he does, once again, with this woman who caught his attention as he walked up the aisle.

▼ "Our vocation is to be lived in joy," Pope Francis reminds priests, men and women of consecrated life, and laity gathered for vespers at St. Patrick's Cathedral.

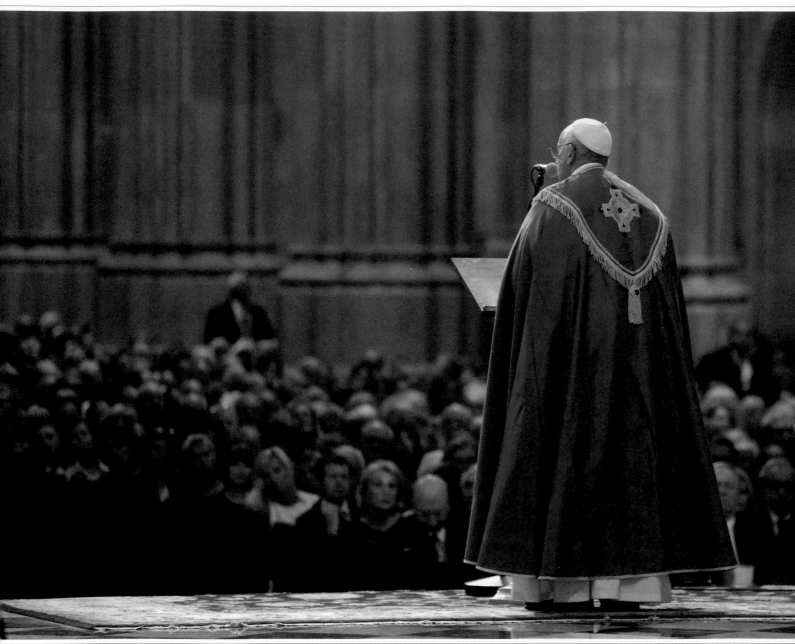

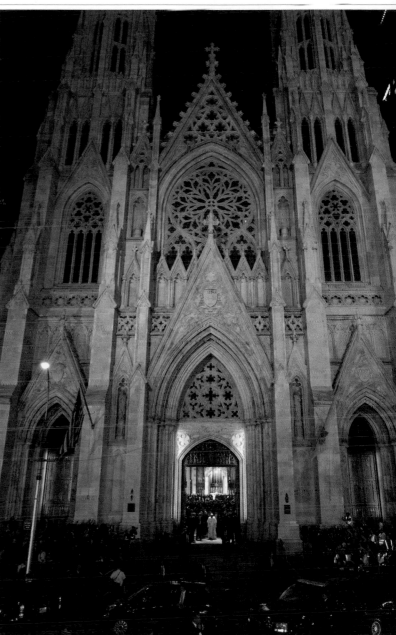

This cathedral, says the pope, "can serve as a symbol of the priests and religious and lay faithful who helped build up the Church in the United States."

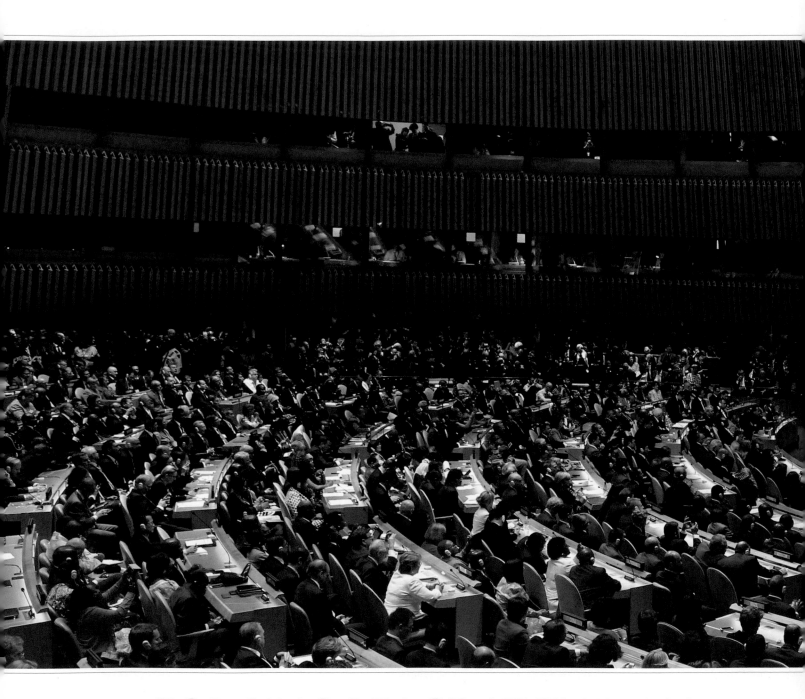

FORGING PEACE AT THE U.N.
POPE FRANCIS CALLS FOR URGENT ACTION

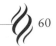

To an audience of world leaders and diplomats at the United Nations, Pope Francis spoke of environmental concerns and social justice. "A selfish and boundless thirst for power and material prosperity leads both to the misuse of available natural resources and to the exclusion of the weak and disadvantaged," he said. He begged for peace in the face of violence and the elimination of all nuclear weapons, rather than "lists of problems, strategies, and disagreements."

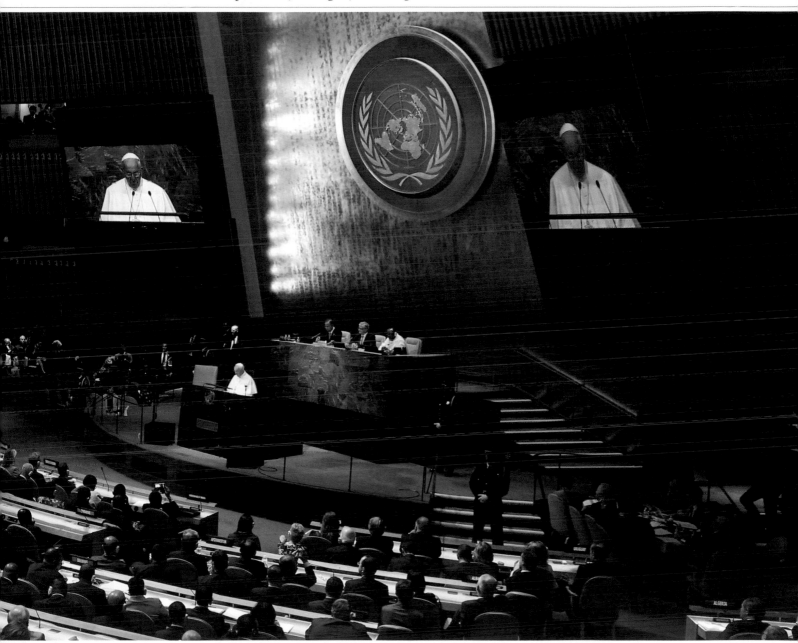

⌃ The pope tells members that he prays the U.N.'s service will be respectful of diversity and able to bring out the best in each individual.

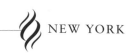

The Holy See and the United Nations

"NO MORE WAR, WAR NEVER again!" Those historic words of Pope Paul VI were spoken in 1965, during his address to members of the General Assembly of the United Nations. Paul VI was the first of four popes who have spoken before the assembly. John Paul II (1979 and 1995) and Pope Benedict XVI (2008) followed in Pope Paul's footsteps at the U.N., as well as, of course, Pope Francis on this September day.

The Holy See's involvement with the U.N. began in April 1964, when it was given the status of permanent observer state. In that capacity, the Holy See has a standing invitation to attend, as an observer, all sessions of the General Assembly, the U.N. Security Council,

and the U.N. Economic and Social Council, and to maintain a permanent observer mission at U.N. headquarters in New York.

In its activities at the U.N., the Holy See Mission works to advocate for social justice and to advance freedom of religion and respect for the sanctity of all human life. As a matter of diplomatic courtesy, since 1964 the Holy See has been permitted to make formal policy statements in the General Assembly, both during the general debates and during the discussion of the various separate issues contained in the General Assembly agenda.

It is by its own choice that the Holy See enjoys the status of permanent observer at the U.N., rather than that of a full member,

according to the Holy See Mission. This is primarily due to the desire of the Holy See to maintain neutrality on specific political responses to global issues.

In addition to coordinating rare papal addresses to the General Assembly, the Holy See Mission issues statements for the consideration of other U.N. member states, reflecting the Church's understanding of how the nations of the world ought to interact. The permanent observer post is held by Archbishop Bernadito Auza, a seasoned diplomat originally from the Philippines. It is Archbishop Auza's role to bring to the U.N. the Church's moral vision, and the breadth of the Church's experience across national boundaries, worldwide.

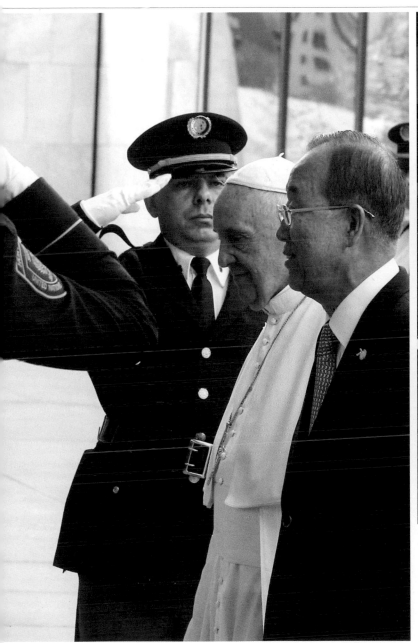

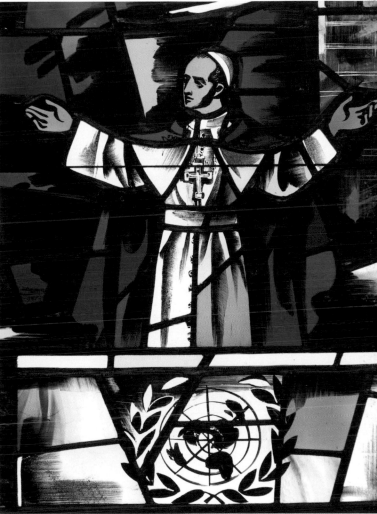

U.N. Secretary-General Ban Ki-moon and the pope enter the U.N. building, where hundreds of diplomats and world leaders are gathered.

"Human genius, well applied, will surely help to meet the grave challenges of ecological deterioration and of exclusion."

—POPE FRANCIS TO U.N. GENERAL ASSEMBLY

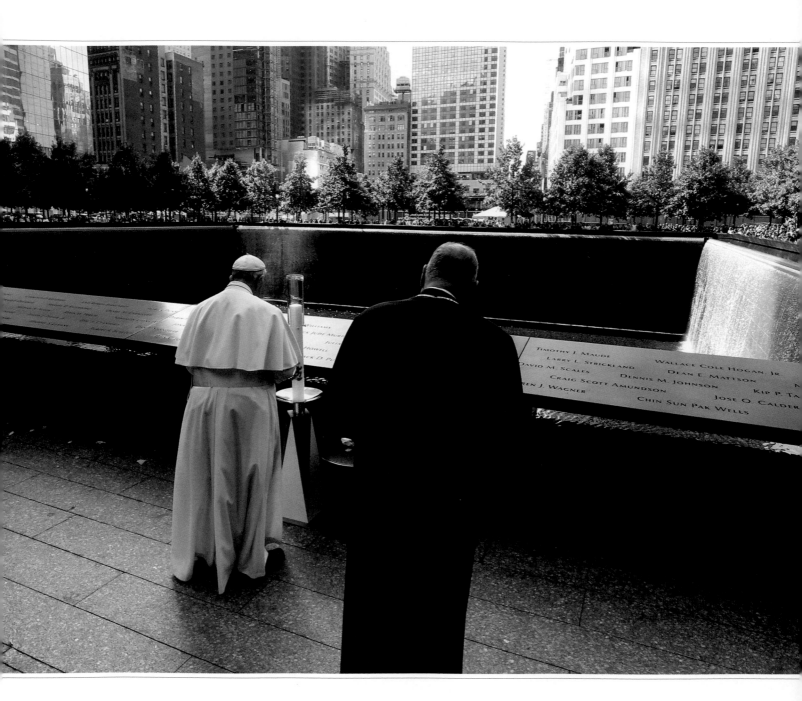

MOMENTS OF REMEMBRANCE
HEALING AND DIALOGUE AT GROUND ZERO

Following his address to the United Nations, Pope Francis visited the National September 11 Memorial and Museum. Before meeting with victims' families and leaders of various faiths, he paused for a moment of prayer by the south reflecting pool at the memorial. "The names of so many loved ones are written around the towers' footprints. We can see them, we can touch them, and we can never forget them," he solemnly spoke.

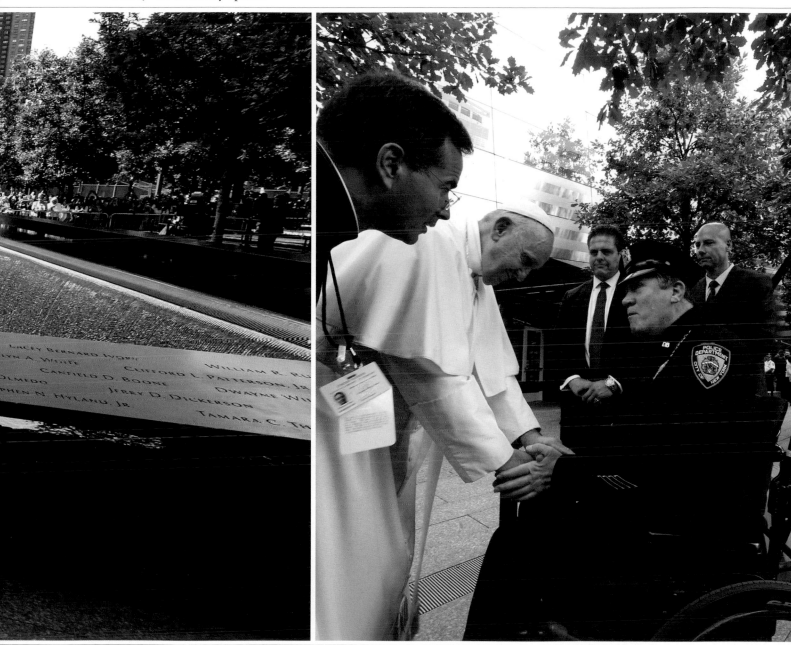

▲ The work of 9/11 first responders, such as New York City detective Terrence McGhee, says the pope, is an example of "the heroic goodness which people are capable of."

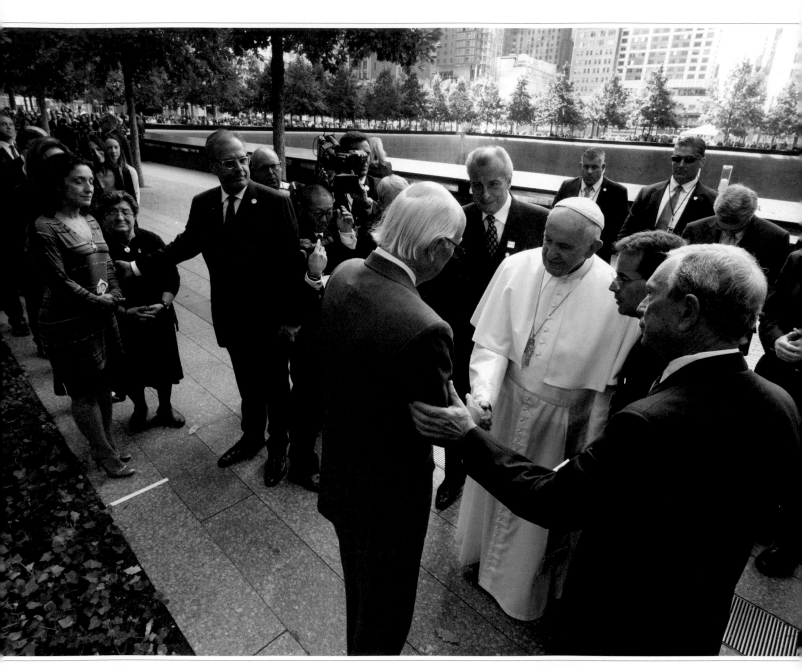

A Family members of those who died on 9/11 greet Pope Francis. For many of those families, his presence is a source of profound comfort.

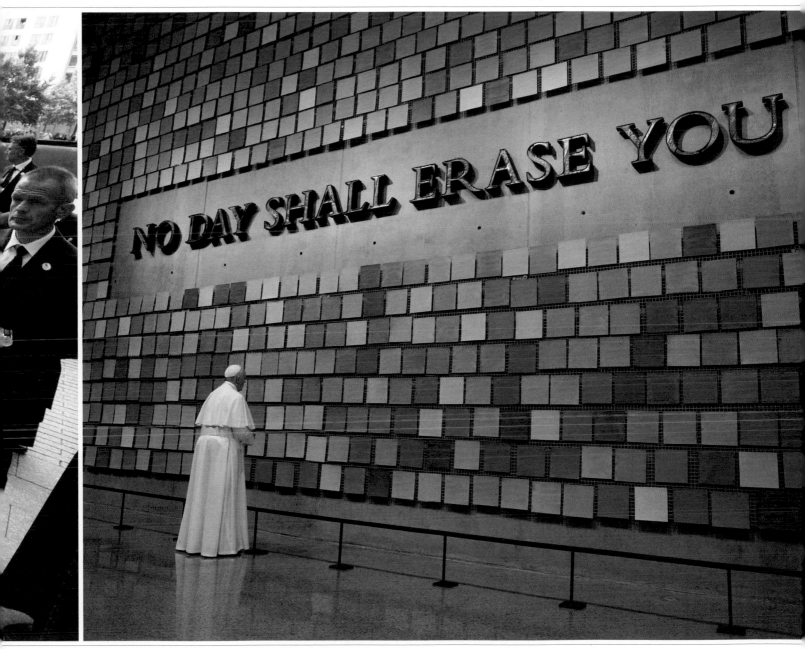

Pope Francis pauses at the National September 11 Memorial and Museum, honoring those who died that day.

▼ Representatives of various faith
communities join Pope Francis in prayer.
"Simply peace," the pope implores.

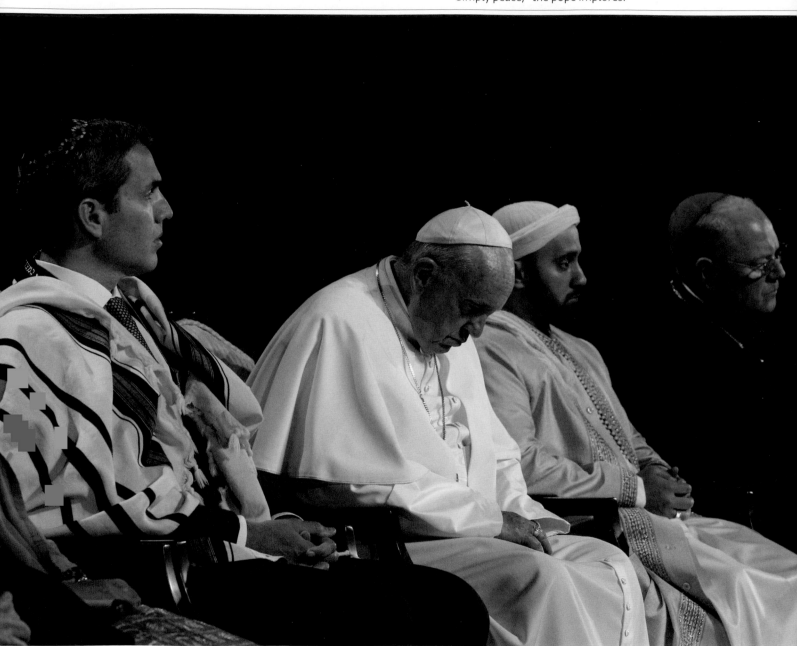

"This is a place where we shed tears, we weep out of a
sense of helplessness in the face of injustice."

—POPE FRANCIS AT 9/11 MEMORIAL

Reaching Out in Love

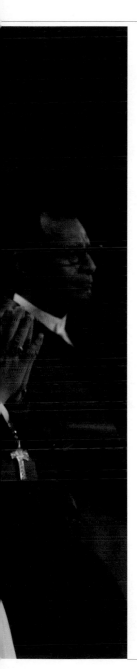

POPE FRANCIS IS NOTHING IF not a builder of unity among peoples. His commitment to making friends and gaining understanding beyond the walls of Roman Catholicism goes back to his days as Archbishop, then Cardinal, Bergoglio in Buenos Aires.

Who can forget the 2014 embrace of the Holy Father with longtime Argentine friends Rabbi Abraham Skorka and Muslim leader Omar Abboud at the Western Wall in Jerusalem? The rabbi and the future pope actually had written a book together about Judaism and Christianity, *On Heaven and Earth*. That title says something about the scale of the pope's quest for unity. He's repeated that outreach with Hindu, Buddhist, Sikh, and atheist leaders.

Pope Francis's appeal for understanding across faiths is not naive. In a January 2015 speech in Sri Lanka, a nation of many faiths where Christians are a minority, he noted that for such dialogue and encounter to be effective, it must be "grounded in a full and forthright presentation of our respective convictions."

Each faith group brings something of value to the table, while respecting and seeking to understand the faith of the other. "If we are honest in presenting our convictions, we will be able to see more clearly what we hold in common," he said then.

The first step? It is simply to share the experience of being human. The pope wrote this in his very first formal teaching, the Joy of the Gospel (*Evangelii*

Gaudium). "In this way we learn to accept others and their different ways of living, thinking, and speaking. We can then join one another in taking up the duty of serving justice and peace, which should become a basic principle of all our exchanges." At the 9/11 memorial, Pope Francis picked up on this theme: "Together we are called to say 'no' to every attempt to impose uniformity and 'yes' to a diversity accepted and reconciled."

In the memorial museum, underground from the memorial itself, the Holy Father joined an interfaith leaders' group, each of whom spoke a word of peace and reconciliation. That peace, that reconciliation, that interfaith understanding is a constant concern of Pope Francis.

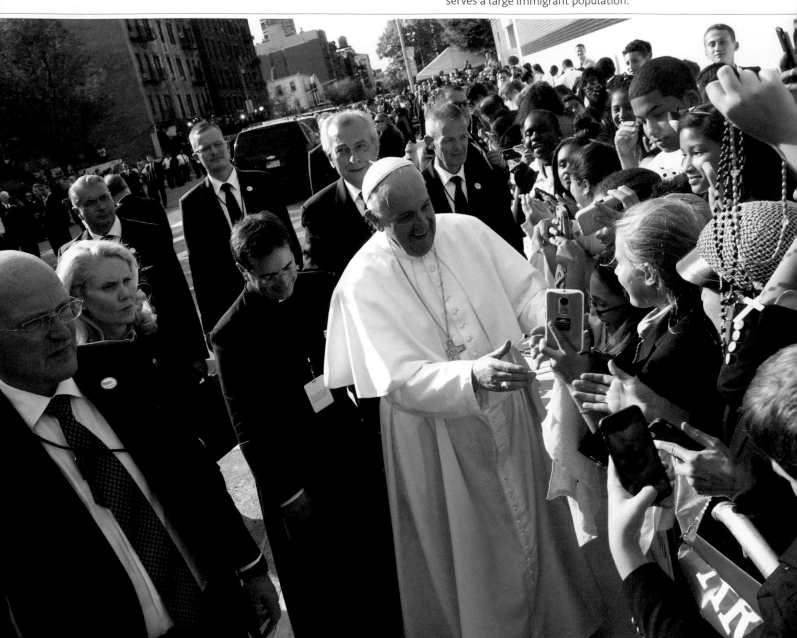

▼ Pope Francis arrives at Our Lady Queen of Angels School in the East Harlem neighborhood in New York. The school serves a large immigrant population.

EDUCATION FOR EVERYONE
INNER-CITY SCHOOL WITH A MISSION

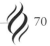

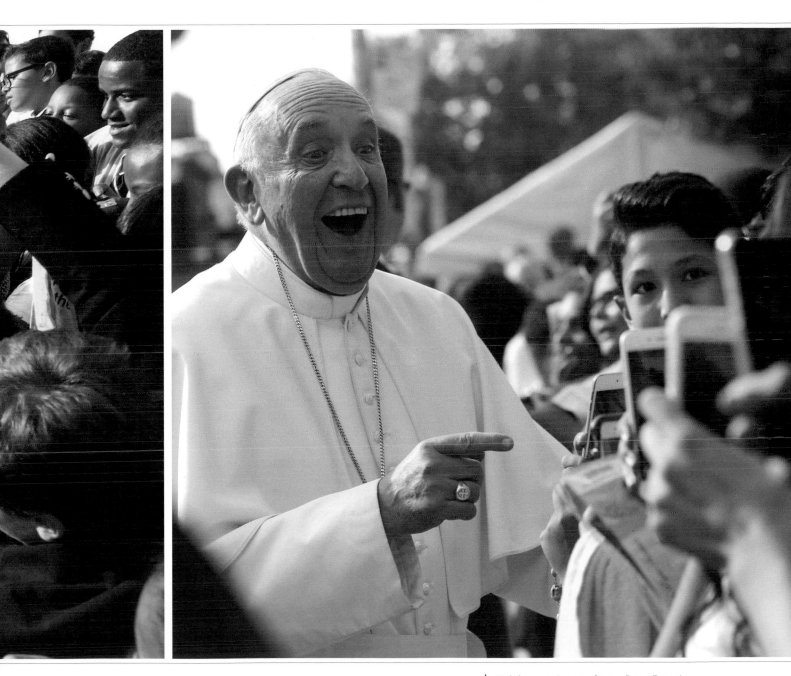

⟡ While greeting students, Pope Francis demonstrates his message for them: "Keep smiling and help bring joy to everyone you meet."

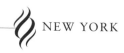
Our Lady Queen of Angels School

THE WELL-BEING OF children has been one of Pope Francis's chief objectives since his papacy began. It was little surprise, then, that the New York leg of his trip to the United States included time spent in an inner-city Catholic school.

Our Lady Queen of Angels (OLQA) is a bustling educational community that reflects its diverse East Harlem neighborhood. Students at the elementary school identify as 70 percent Hispanic and 22 percent African American, of whom 22 percent are English-language learners. Almost 70 percent qualify for need-based scholarships, the school reports.

The administrators and teachers at OLQA strive to far surpass the state's requirements for reading, writing, science, and mathematics. The development of individual worth, moral character, and a deep understanding of civic responsibility are also a daily part of the curriculum. OLQA's mission is to prepare each student to give back to the neighborhood, the nation, the world.

Pope Francis's visit to OLQA sheds light on the struggles of Catholic schools across the United States. According to a 2014–2015 report from the National Catholic Educational Association (NCEA), there are 1.9 million students in 6,568 Catholic schools in the United States: 5,368 elementary, 1,200 secondary. Of that number, the NCEA reported that 20.4 percent of the students are members of racial minorities. This is in stark contrast to the 1960s, when there were more than 5.2 million students in nearly 13,000 schools. The diversity of Catholic students today continues to increase—even as the number of schools decreases.

But statistics were not on the pope's mind during his visit.

"I would like to give you some homework," he said to the children. "It is a simple request, but very important: Please don't forget to pray for me, so that I can share with many people the joy of Jesus."

The pope has often preached that children are gifts to our human family—investments in a just future. Their education, protection, and care are not merely our duty, but their birthright, says the former teacher.

"His dream was that many children like you could get an education," Pope Francis tells students, recalling the Rev. Martin Luther King Jr.

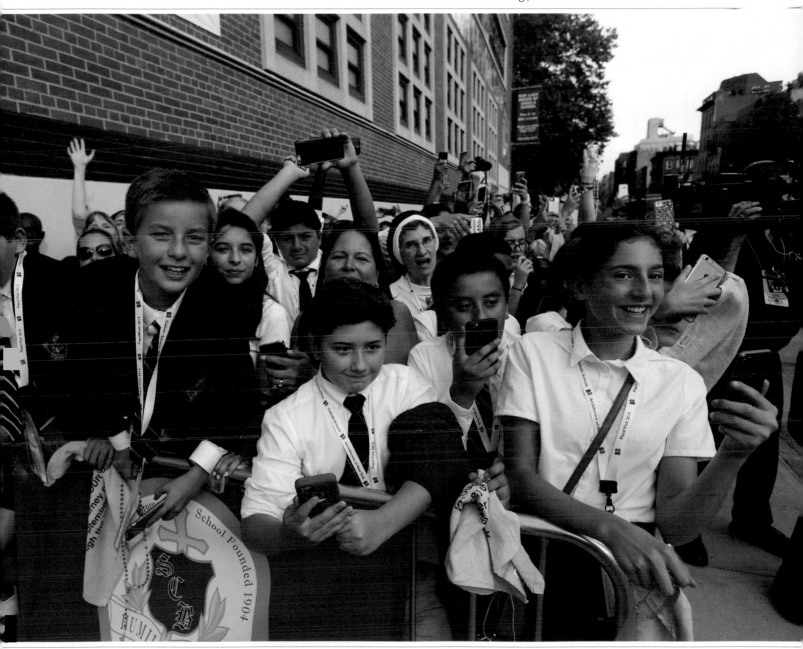

Pope Francis @Pontifex

Thank you to all teachers: educating is an important mission, which draws young people to what is good, beautiful, and true.

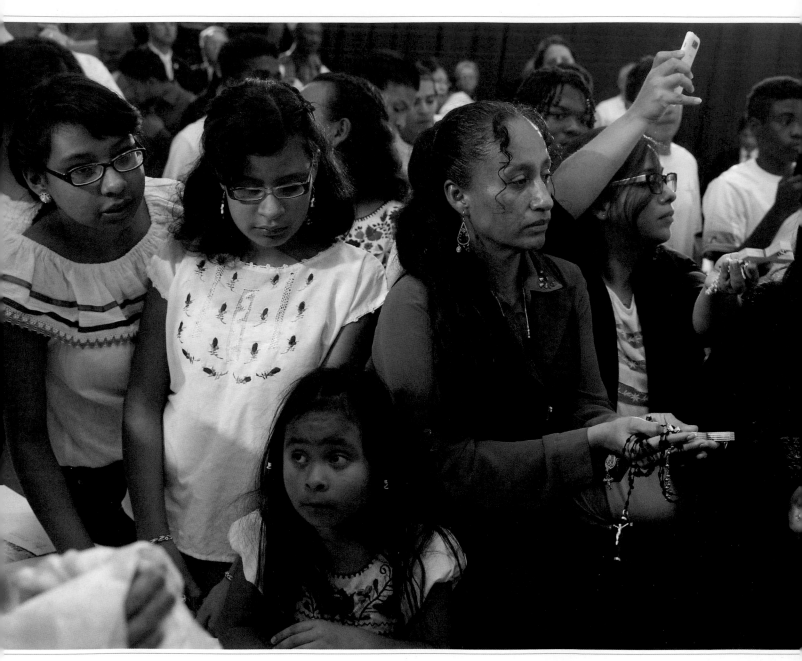

∧ Families hold out religious articles during
Pope Francis's visit. School, he says, can be
like one big family.

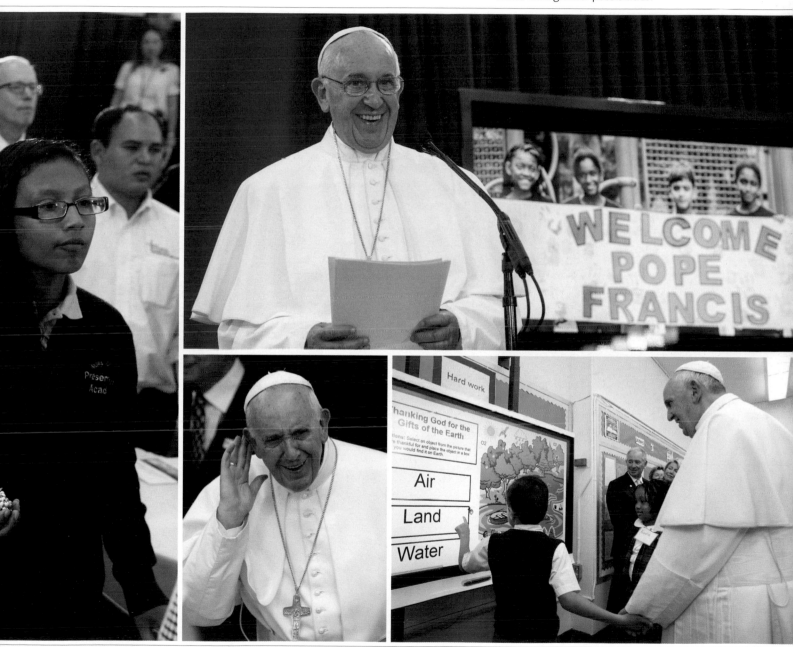

Pope Francis asks those in attendance to "celebrate all the opportunities which enable you not to lose the hope of a better world with greater possibilities."

The pope listens closely after encouraging the students to sing for him. "Now, all together...one song," he, ever the teacher, tells them.

"You have to double-click it," a student tells a tech-challenged Pope Francis while demonstrating the classroom's Smart Board.

▼ Pope Francis greets twenty thousand people in Madison Square Garden. During their several-hour wait, some of them receive the sacrament of reconciliation.

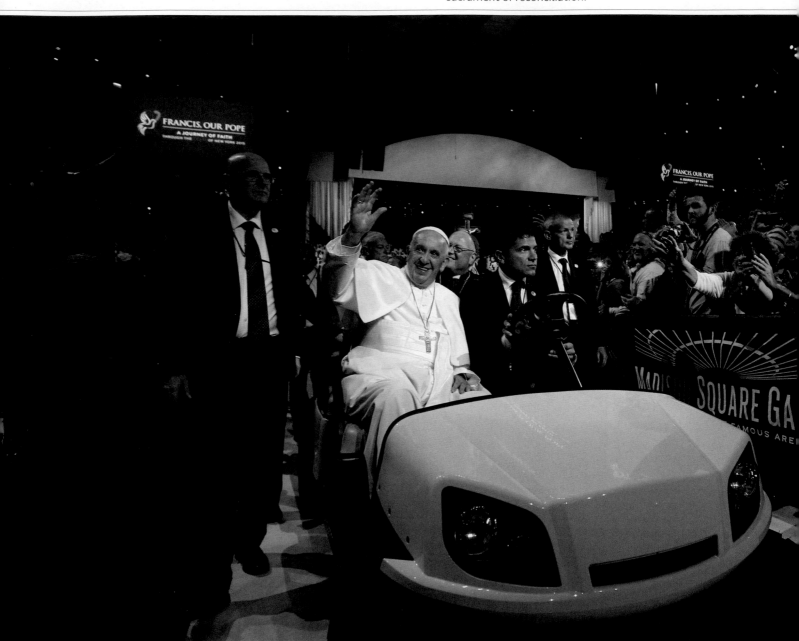

HEART OF THE BIG APPLE
STANDING-ROOM-ONLY AT MADISON SQUARE GARDEN

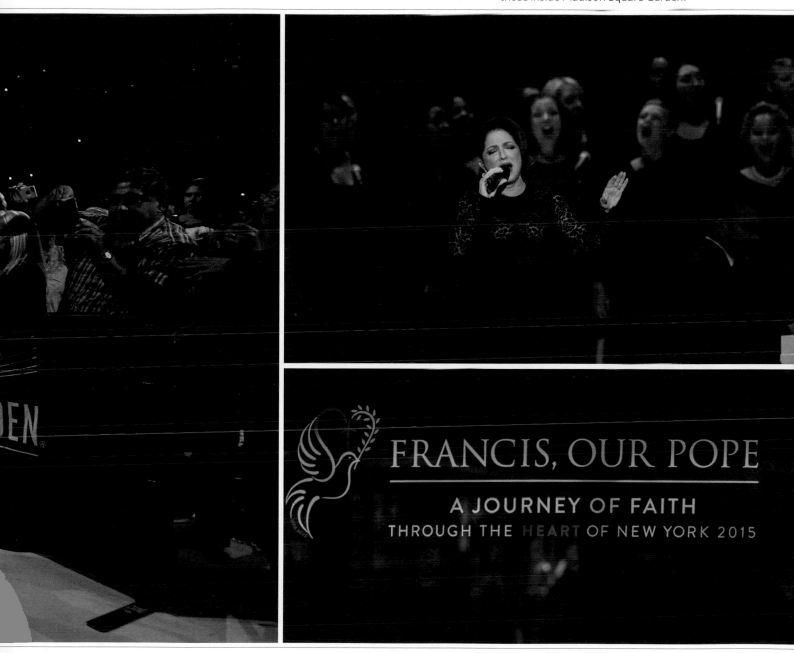

▼ Gloria Estefan performs before the start of Mass. Other performers keep up the spirit of those inside Madison Square Garden.

FRANCIS, OUR POPE

A JOURNEY OF FAITH
THROUGH THE HEART OF NEW YORK 2015

▲ The city made its own slogan for the papal visit, one that emphasizes "a faith—and a city—soaring: empowered by tolerance...and heralding peace and love."

▼ Cardinal Timothy Dolan beams as Pope
Francis waves to the people. His cart goes up
and down several aisles, enabling him to see
more people and to kiss a few babies.

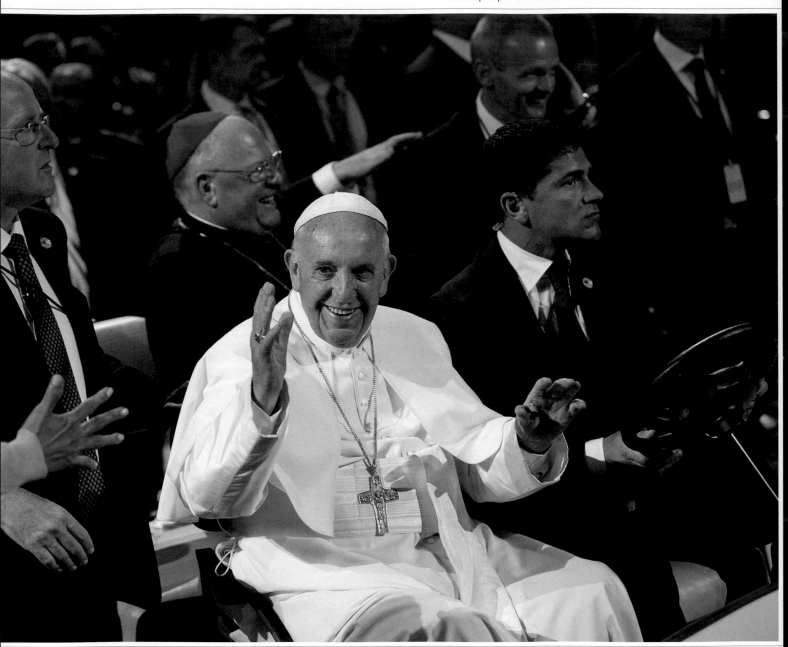

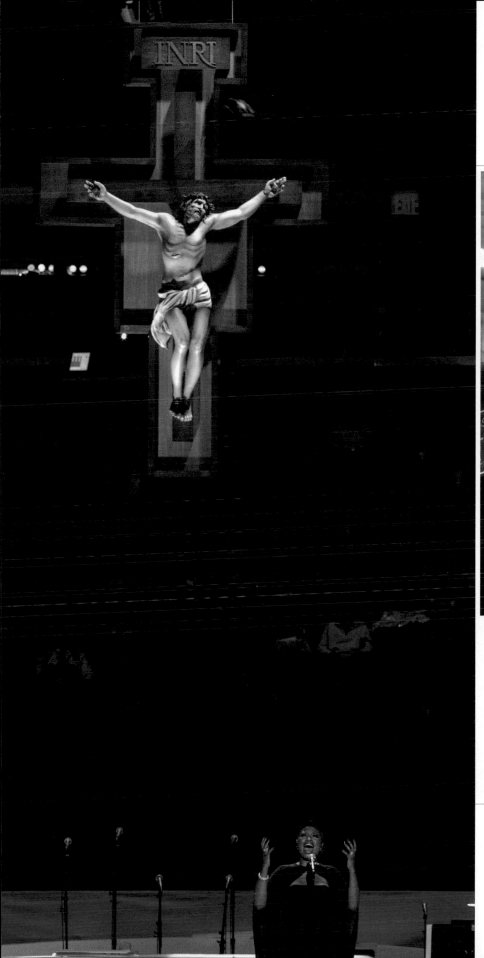

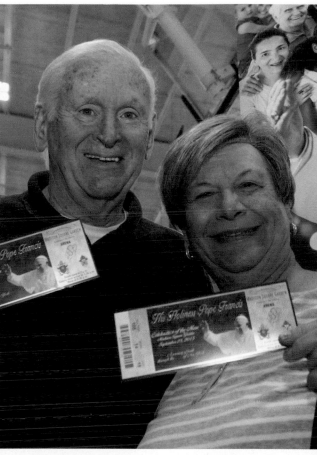

▼ Harold and Carmela Lubeski of Curé of Ars Parish in Merrick, New York, won two of the one thousand attendance tickets distributed by lottery through the Diocese of Rockville Centre, New York.

◄ Renowned performer Jennifer Hudson has no trouble holding people's attention in a venue generally used for other purposes— but today to pray with Pope Francis.

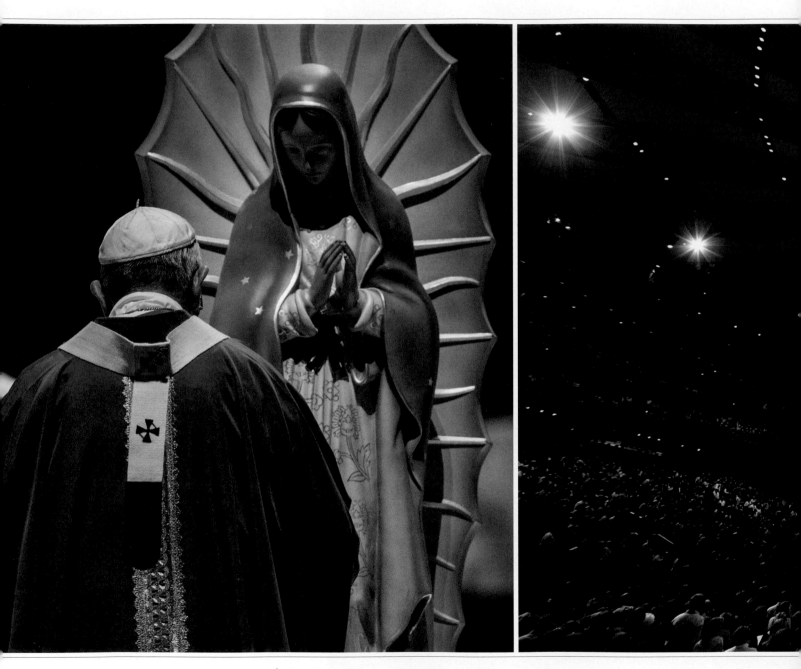

Λ Pope Francis prays before a statue of Our
Lady of Guadalupe. He urges those gathered
to meet others "where they really are, not
where we think they should be."

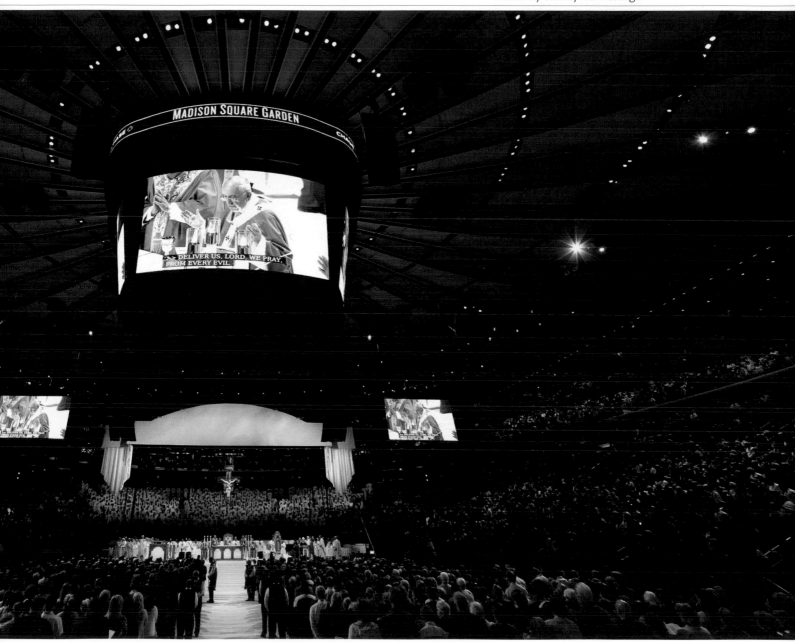

"God our Father frees us from anonymity, a life of emptiness, and brings us to the school of encounter."

—POPE FRANCIS AT MADISON SQUARE GARDEN

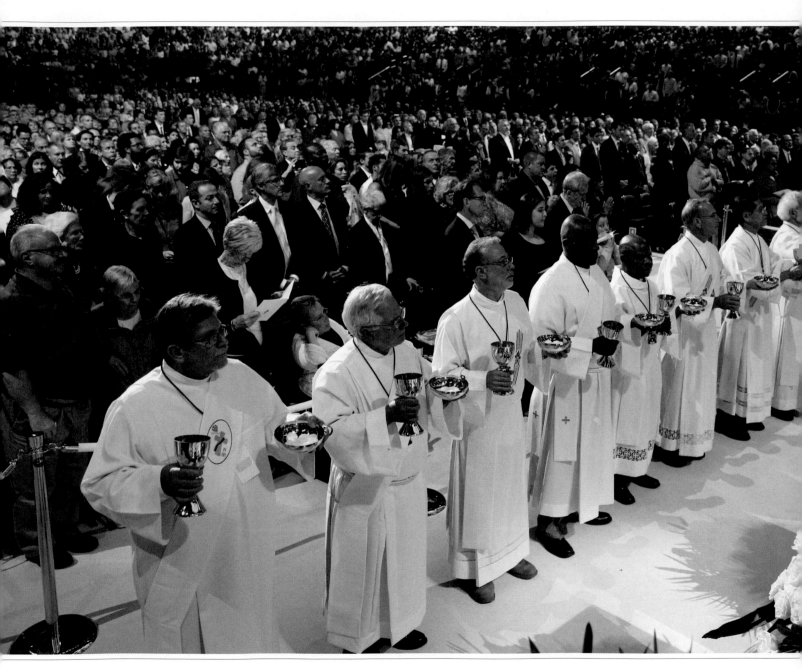

▲ Deacons prepare to distribute Communion to congregants. They have heard a papal reminder that Christian hope frees people from isolation and self-absorption.

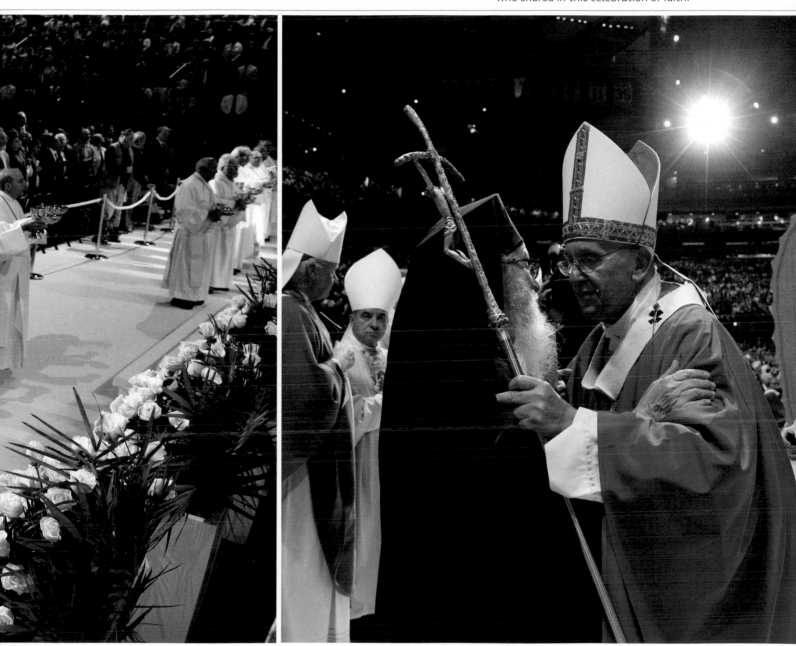

At the conclusion of Mass, Pope Francis greets one of the many Christians leaders who shared in this celebration of faith.

PHILADELPHIA

It was the reason he came to America: the World Meeting of Families, in Philadelphia this year. By the time he deplaned at Atlantic Aviation, he had already made history again and again, in the days preceding. But that didn't stop him from enjoying—and energizing—the Festival of Families on Saturday and the World Meeting that had been taking place all week. There were liturgies, talks to bishops from around the world, and a visit to a local prison. On Saturday evening he showed his joyful enthusiasm when he cast aside his prepared talk and spoke from his heart. "The most beautiful thing that God did [at creation] was the family," said the pope to a lively crowd.

CATHEDRAL BASILICA
THE HOLY FATHER ASKS ALL OF US: "WHAT ABOUT YOU?"

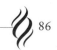

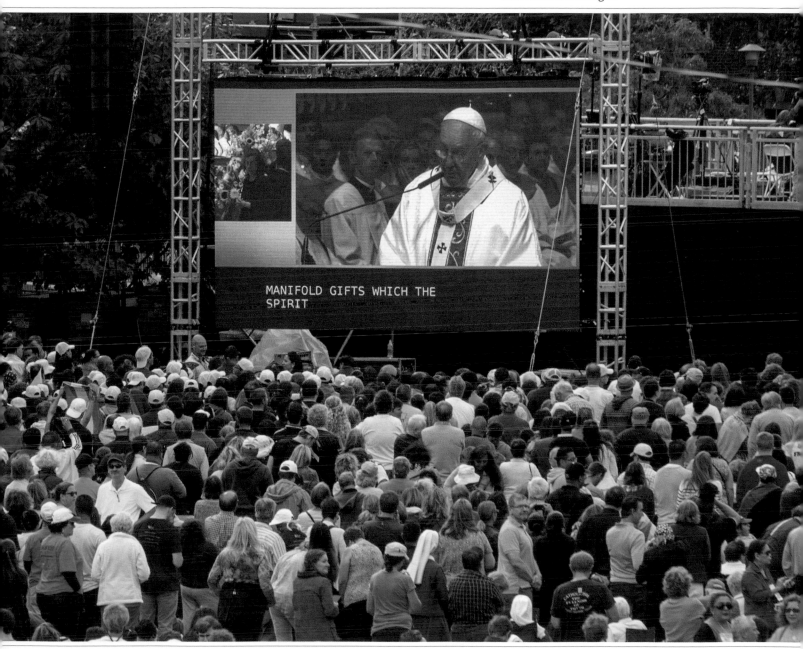

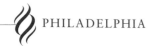

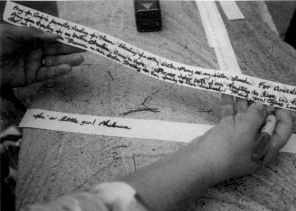

▼ Written in blue marker on a strip of cloth, this woman's prayer intention is a contribution to the Knotted Grotto art installation outside the basilica.

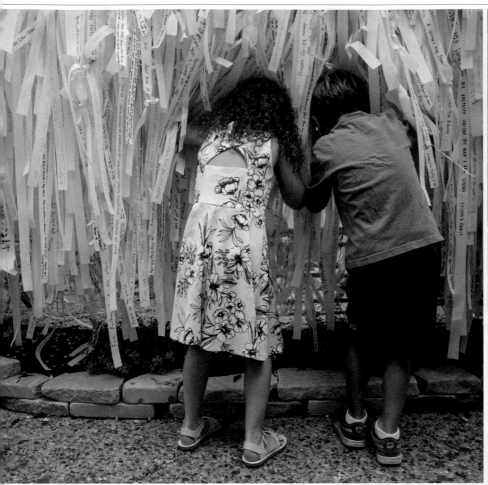

▲ Two six-year-olds peer through some of the one hundred thousand prayer intentions at the Knotted Grotto, a project inspired by the image of Mary, Undoer of Knots.

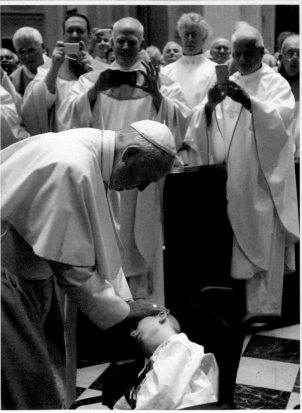

▲ The crowds aren't the only ones with cell phones readied. Representatives of the Philadelphia Archdiocese snap photos of the pope blessing a boy in a wheelchair.

"Each one of us has to respond, as best we can, to the Lord's call to build up his Body, the Church."

—POPE FRANCIS AT CATHEDRAL BASILICA OF STS. PETER AND PAUL

As the incense rises at the beautiful Cathedral Basilica of Sts. Peter and Paul, so does the excitement over the pope's visit to the City of Brotherly Love.

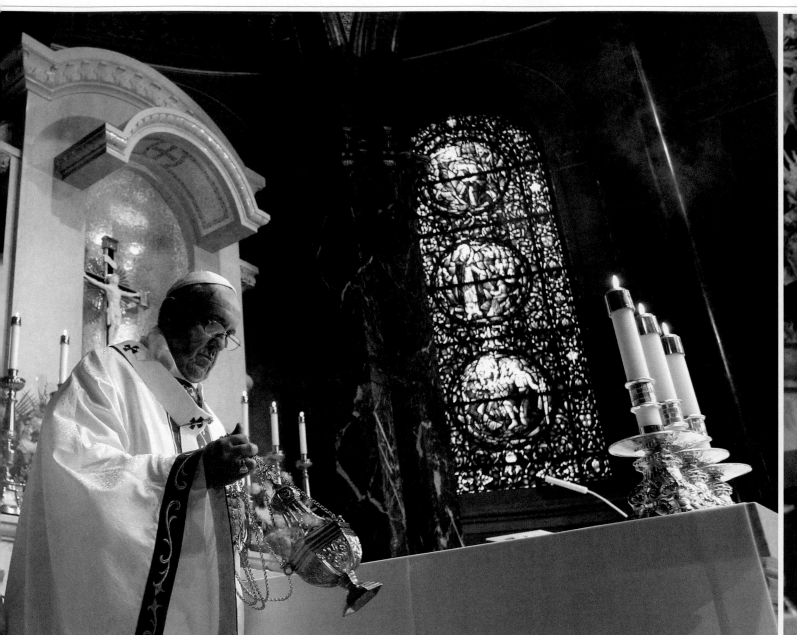

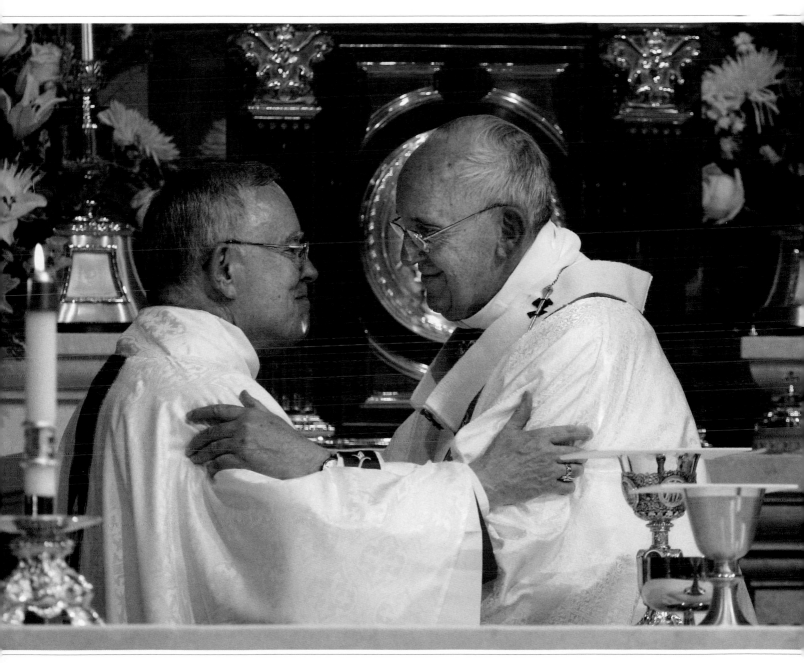

⌃ More than fifteen hundred people celebrate
the Eucharist along with Pope Francis, who
exchanges a cordial sign of peace here with
Archbishop Charles Chaput.

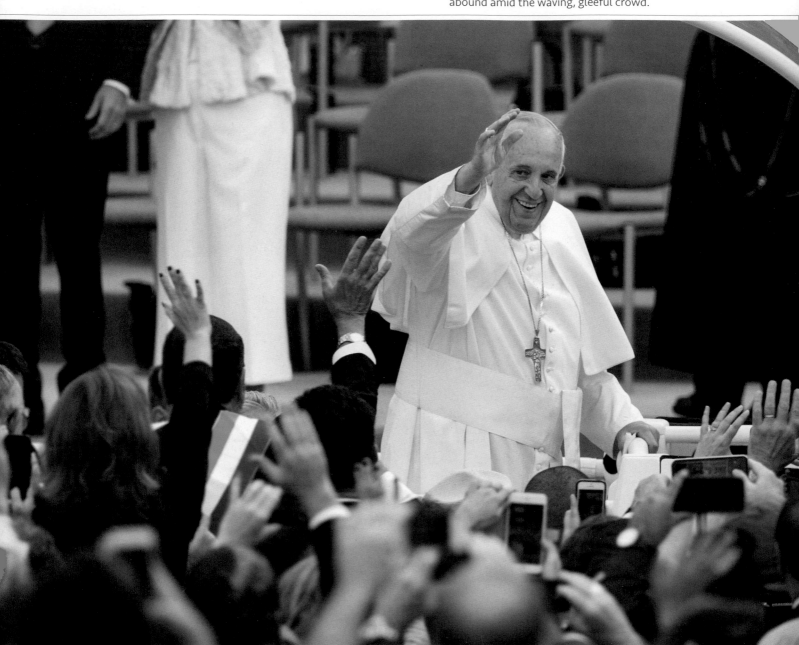

▼ Pope Francis arrives at Independence Hall where, like everywhere, camera phones abound amid the waving, gleeful crowd.

BIRTHPLACE OF DEMOCRACY
TALK OF RELIGIOUS FREEDOM AND IMMIGRATION

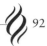

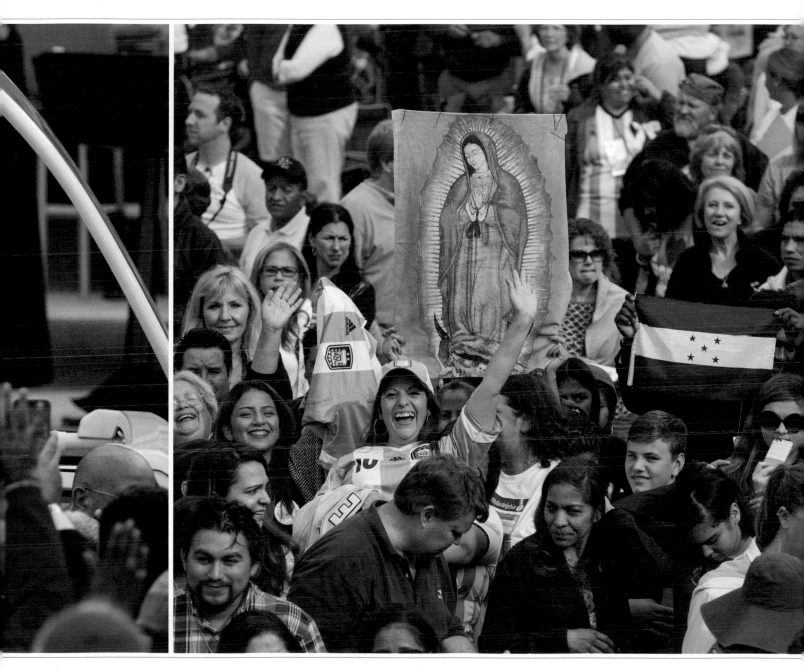

▲ "Do not be discouraged by whatever hardships you face," the pope tells the large Hispanic contingent in the crowd.

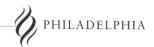
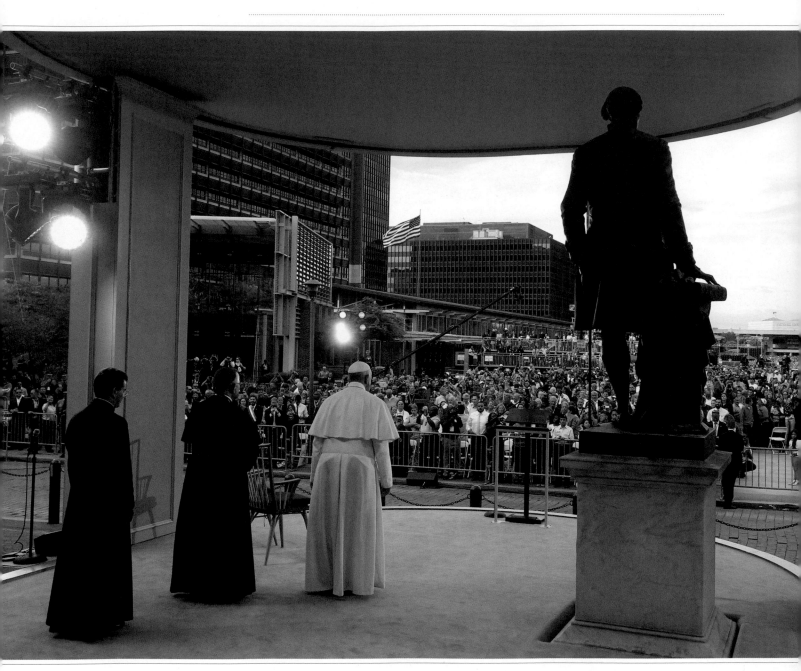

Pope Francis @Pontifex

That which gives us true freedom and true happiness is the compassionate love of Christ.

⋀ Standing in front of historic Independence Hall is one of the highlights of his visit, says the pope before an estimated crowd of fifty thousand.

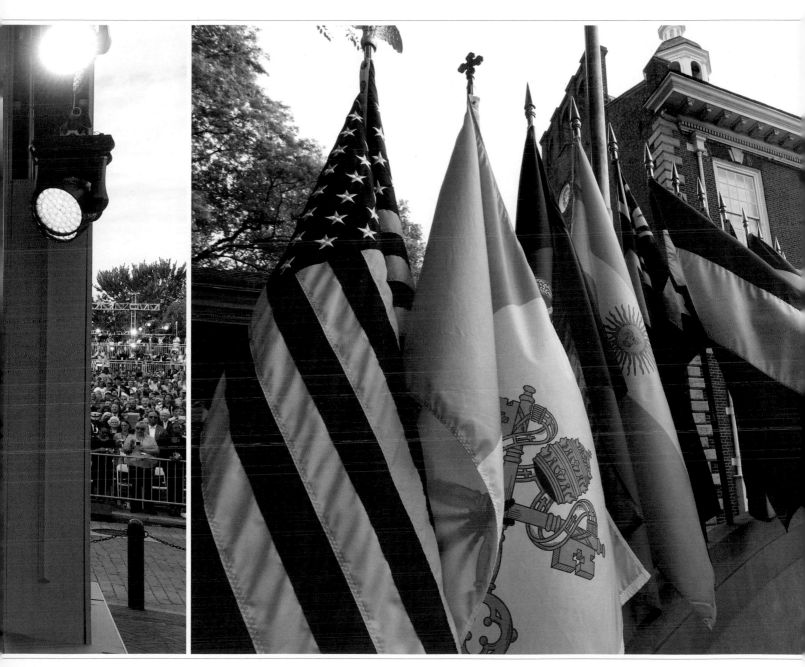

^ Outside Independence Hall, the Vatican
flag is flanked by that of the United States
and other nations represented at the World
Meeting of Families.

▼ Philadelphia Archbishop Charles Chaput, a Franciscan, speaks to the crowd. It was he who formally invited Pope Francis to visit the United States.

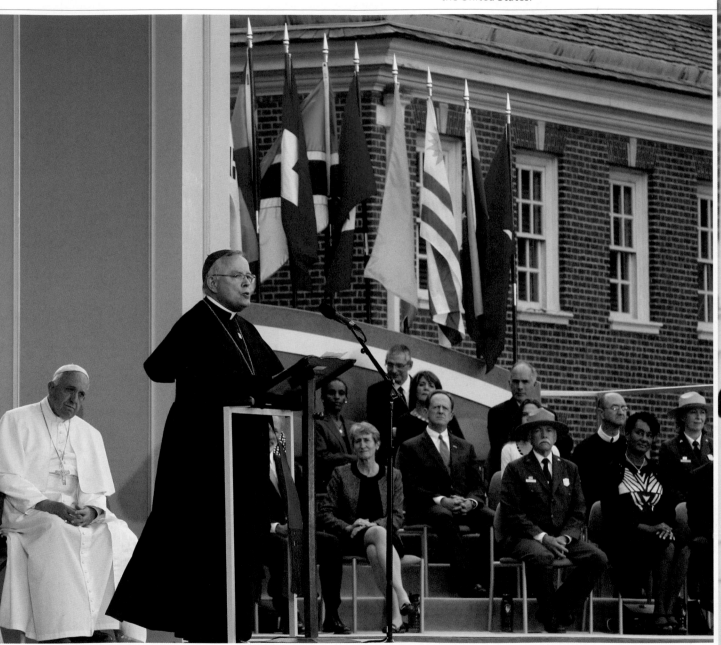

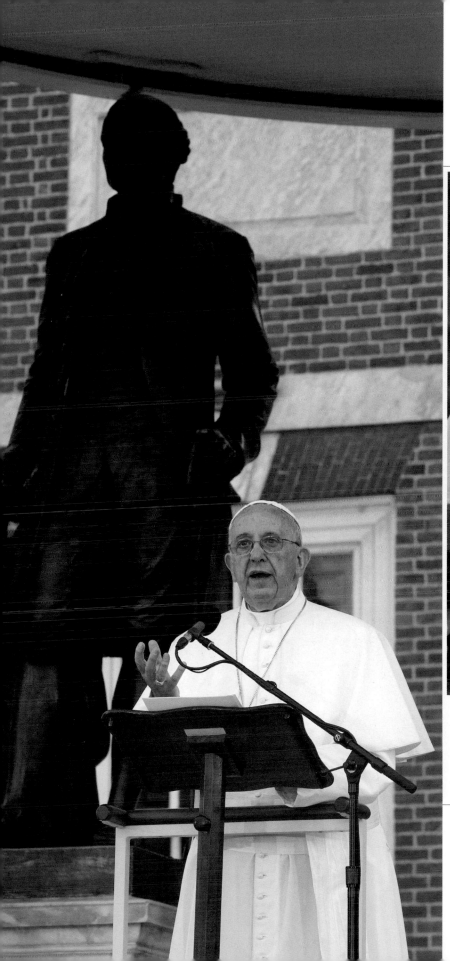

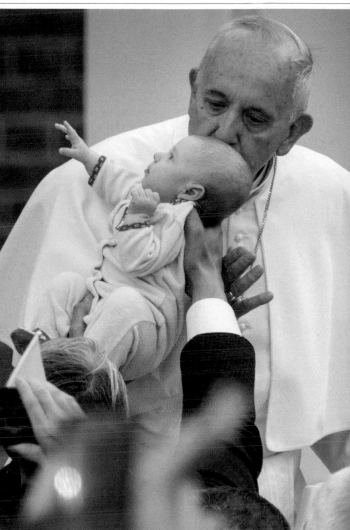

◄ Pope Francis gives his address from the same lectern used by President Abraham Lincoln to deliver the Gettysburg Address.

Ʌ A father holds up his daughter for a kiss from Pope Francis. Everywhere the pope goes, people hope for a chance to get close to him.

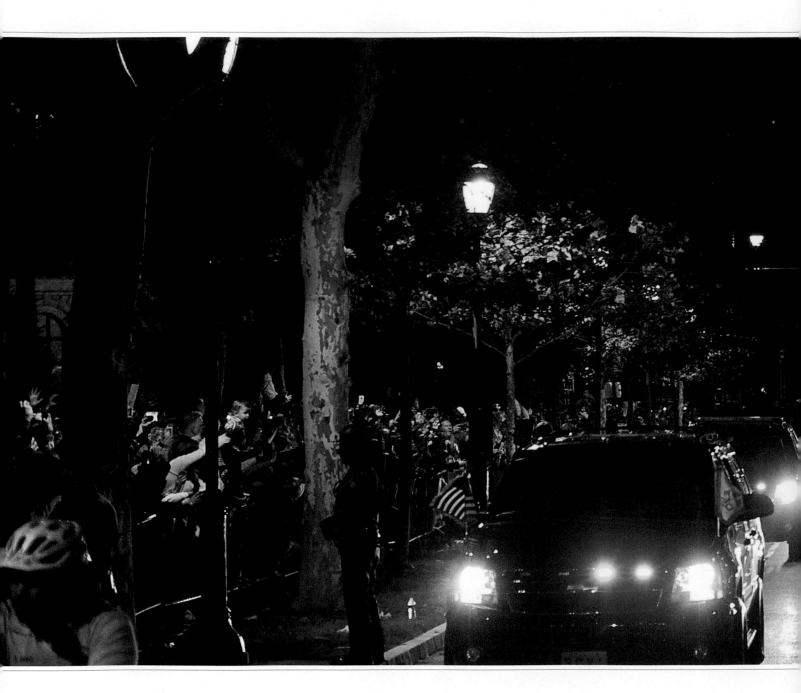

FESTIVAL OF FAMILIES
A JOYOUS CELEBRATION

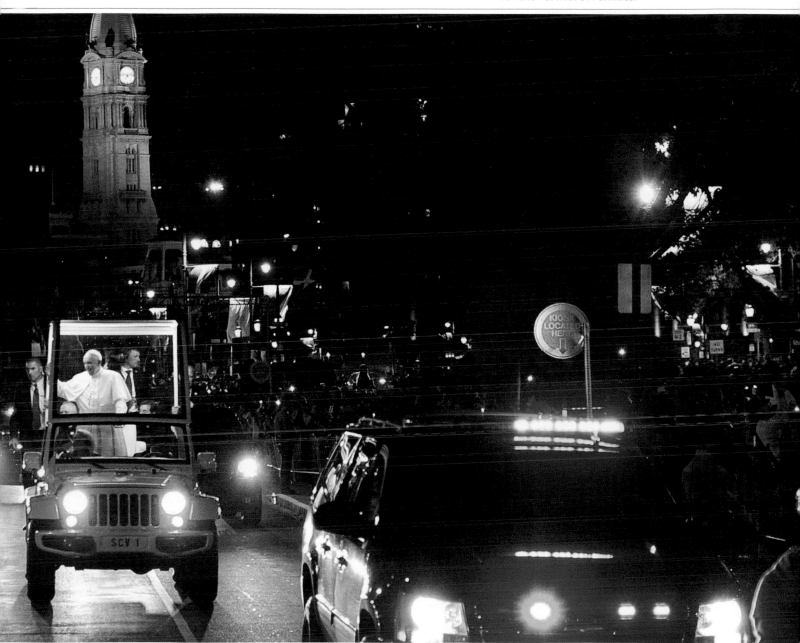

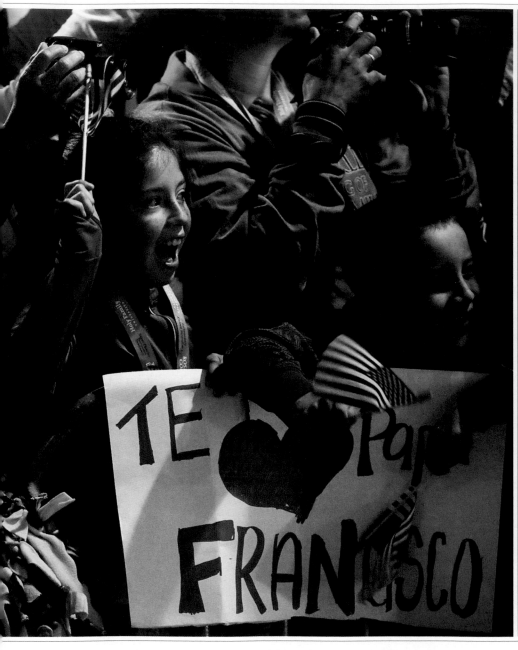

⋏ Many of the messages on signs are in
Francis's native tongue, Spanish. This
one, held by two exhilarated children, is
translated, "I love you, Pope Francis."

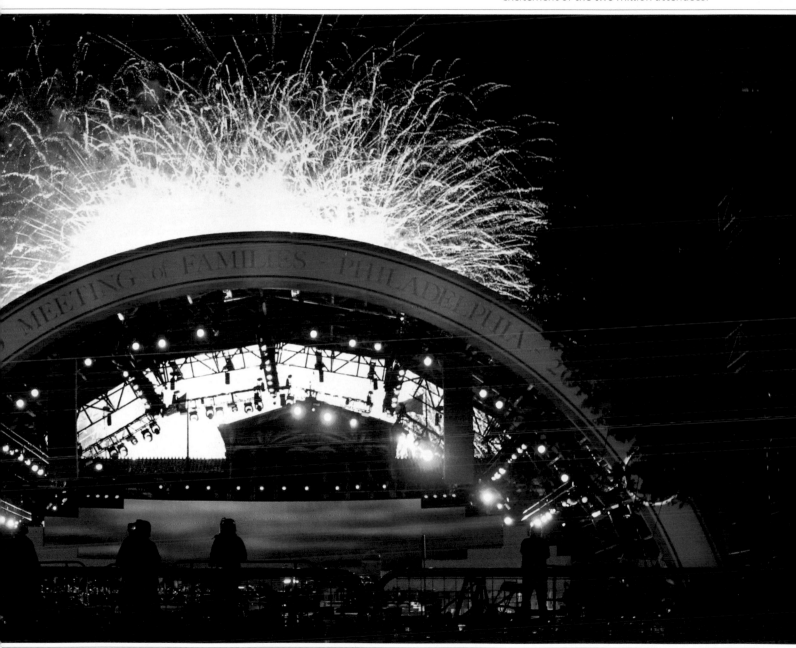

A dazzling fireworks display signals the conclusion of the 2015 World Meeting of Families. It's a fitting symbol of the excitement of the two million attendees.

▼ Philadelphia's own Sister Sledge performs
their 1979 hit, "We Are Family," in front of an
exuberant crowd. It's a family celebration!

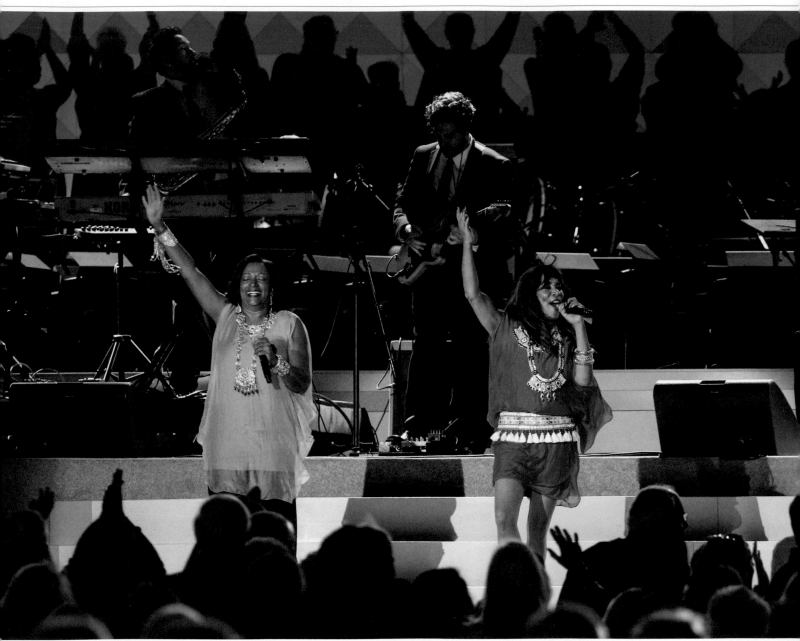

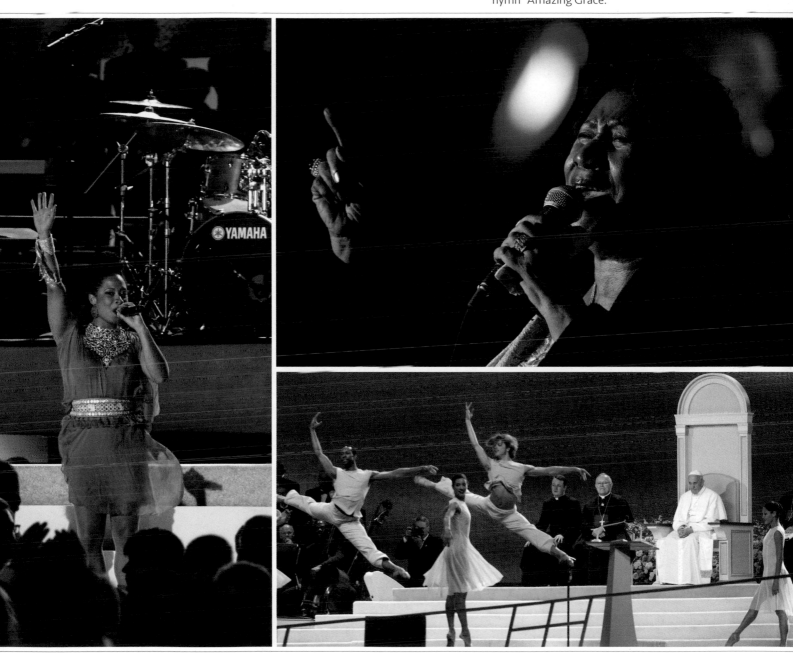

"Queen of Soul" Aretha Franklin, in her signature mezzo-soprano delivery, belts out a powerful rendition of the classic Christian hymn "Amazing Grace."

Beyond musical acts, a graceful performance by the Philadelphia Ballet stands out at the celebration of faith and culture at the World Meeting of Families.

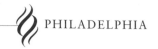
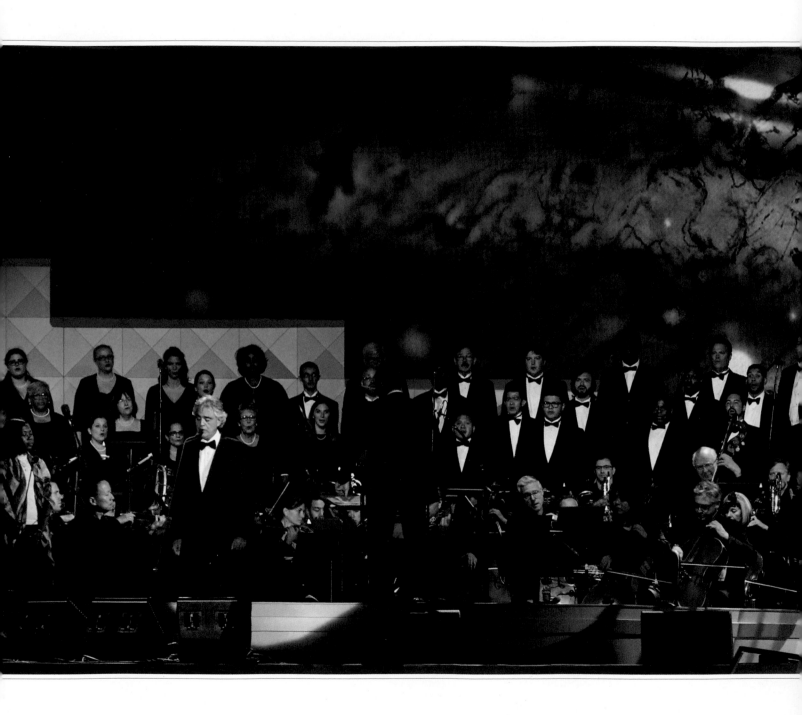

The Philadelphia Orchestra provides backing for world-famous Italian tenor Andrea Bocelli, a Catholic, as he sings "Our Father" in the presence of Pope Francis.

A Celebration of Society's Foundation

POPE JOHN PAUL II BROUGHT forth the idea to celebrate the family's place within the Church in 1992. The first World Meeting of Families took place in Rome two years later, coinciding with the United Nations' International Year of the Family. The Pontifical Council for the Family, also founded by Pope John Paul II, is responsible for organizing the event.

Gathering every three years, the World Meeting of Families has been hosted by Rio de Janeiro (1997), again in Rome (2000), Manila (2003), Valencia (2006), Mexico City (2009), and Milan (2012). The 2015 World Meeting of Families in Philadelphia marks the first time it has been held in the United States and also the first time that Pope

Francis has participated in it. The event has two patron saints: St. John Paul II ("the pope of the family") and St. Gianna Beretta Molla.

St. Gianna was an Italian wife, mother, and physician who insisted that her fourth child be born, even though the decision put her own life at risk. She died a week after giving birth to her daughter (who attended to this event).

Following a forty-year cause for her sainthood, St. Gianna was canonized by Pope John Paul II in 2004.

The theme of the 2015 World Meeting of Families was *Love Is Our Mission: The Family Fully Alive.* The wording is inspired by St. Irenaeus, who said, "The glory of God is man fully alive."

Philadelphia Archbishop Charles Chaput celebrates its

theme: "In like manner, the glory of men and women is their capacity to love as God loves. And rarely can that love be lived out more intimately and fruitfully than in the family," he writes. He adds, "Marriage is the foundation and the guarantee of the family. And the family is the foundation and the guarantee of society."

The World Meeting seeks to strengthen the bonds of family across cultures and nationalities. The vibrant, weeklong celebration, capped by a papal Mass, is filled with education and reflection, festivity and prayer. Anyone who saw relaxed, animated, and jovial Pope Francis speak at the Festival of Families Saturday night could see that this truly was a highlight of his trip to America.

▼ Hundreds of thousands attend the Festival of Families during the World Meeting of Families, including this sleepy young girl holding fast to her father.

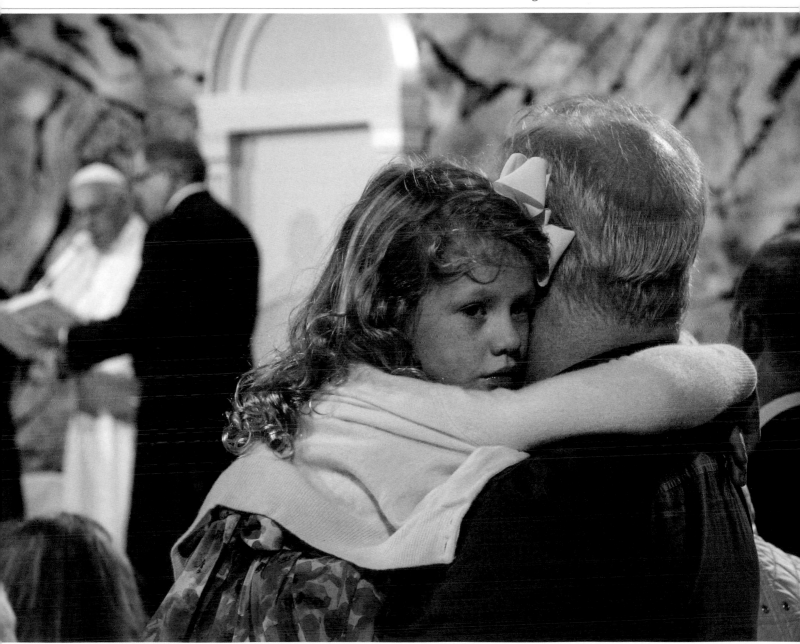

Pope Francis @Pontifex

The family is the greatest treasure of any country. Let us all work to protect and strengthen this, the cornerstone of society.

As he's often done in the past, the pope veers off script to address Saturday evening's audience from his heart. "The family is like a factory of hope," he says.

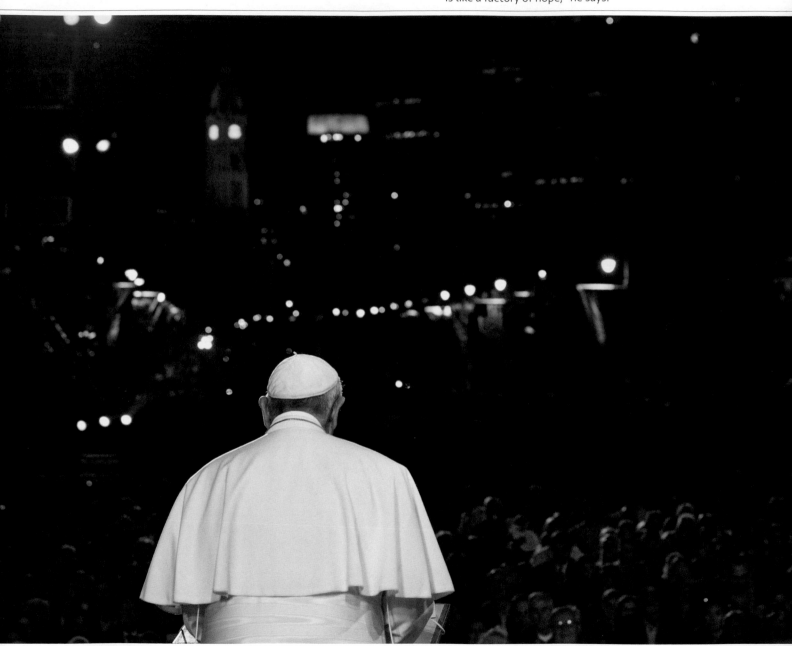

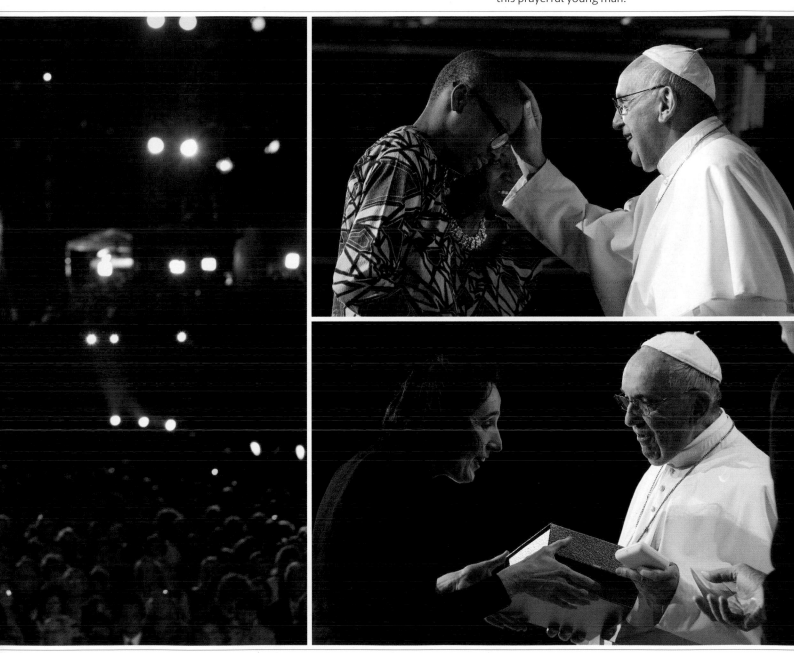

To reach Catholic youth worldwide, the pope relies on Twitter. Here he offers, literally, a hands-on approach to grace as he blesses this prayerful young man.

Dr. Gianna Emanuela Molla, daughter of St. Gianna Beretta Molla, copatron of the World Meeting of Families, enthusiastically greets Pope Francis.

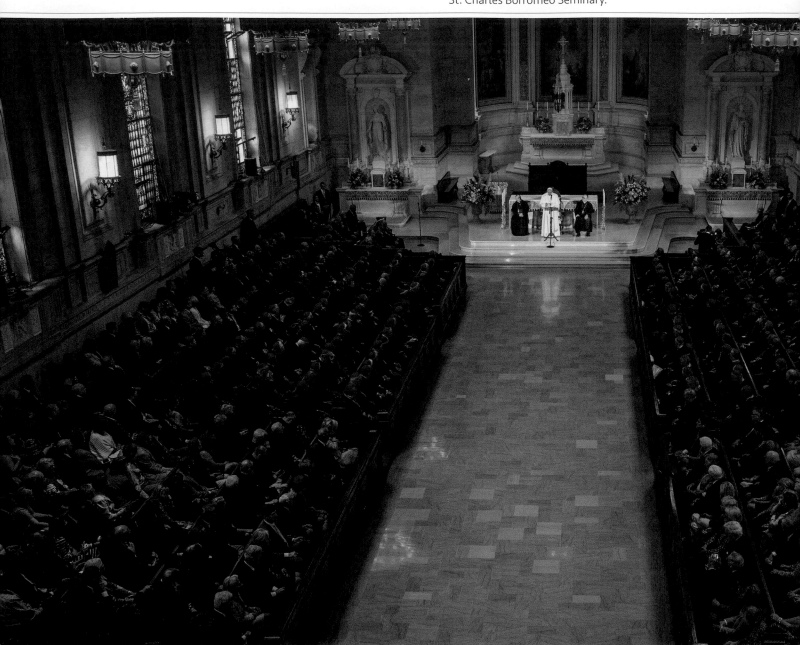

"Our ministry needs to deepen the covenant between the Church and the family," Pope Francis tells a group of Church leaders at St. Charles Borromeo Seminary.

ADVICE TO THE SHEPHERDS
"LIVE IN THE REAL WORLD, BE CLOSER TO REAL FAMILIES"

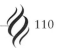

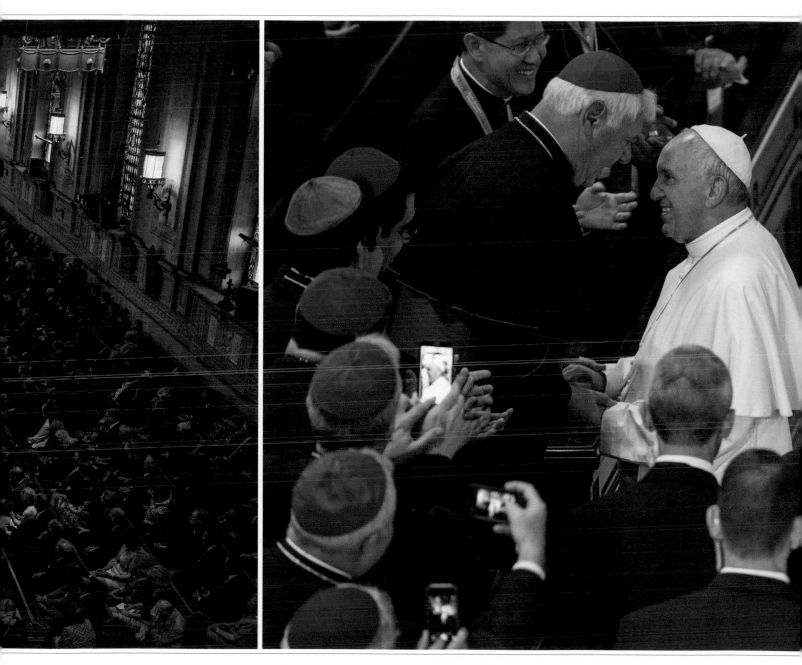

⋏ He came to the seminary to be among his cardinals, like Cardinal Gerhard Müller, here. Moments earlier, the pope met with survivors of sexual abuse, including those abused by clergy.

▼ With his visit to Philadelphia's Curran-Fromhold Correctional Facility, Pope Francis illuminates an oft-forgotten corner in American society.

VISITING THE PRISONERS
"JESUS DOESN'T ASK US WHERE WE'VE BEEN"

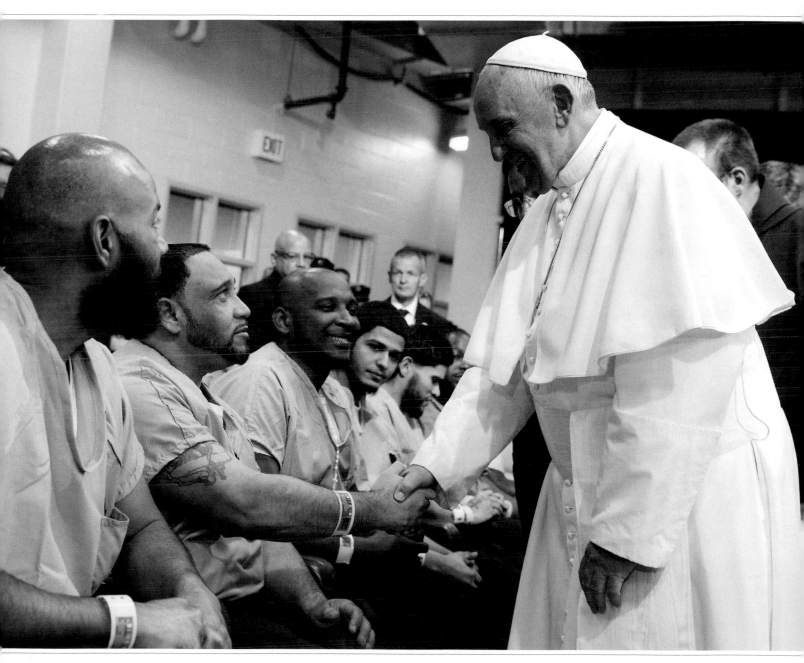

▲ The pope offers inmates more than a hand-
shake. He promises solidarity: "I have come
so that we can pray together and offer our
God everything that causes us pain, but also
everything that gives us hope."

A Man Who Has Experienced Forgiveness

POPE FRANCIS IS A FRIEND to those whom we cast off as "the other."

When he was auxiliary bishop of Argentina, Jorge Mario Bergoglio, now Pope Francis, would spend hours in the slums of his hometown with those whom society had all but forgotten. There he became an advocate for prison reform. His 2015 visit to the notoriously dangerous Palmasola prison in Bolivia spoke to his fearless humility and genuine care for the incarcerated.

"You may be asking yourselves, 'Who is this man standing before us?'" the pope said to prisoners there. "The man standing before you is a man who has experienced forgiveness. A man who was, and is, saved from his many sins." Afterward, the pope hugged and kissed some of the inmates.

He brought that humble spirit to the inmates at Curran-Fromhold Correctional Facility in northeast Philadelphia. "All of us have something we need to be cleansed of, or purified from," the pope told the inmates. The Good Shepherd is close at hand, though: "The Lord goes in search of us; to all of us he stretches out a helping hand."

The pope, an opponent of the death penalty and lengthy prison sentences, thrilled inmates—not to mention advocates of prison reform—by bringing hope and humanity to this sometimes-forgotten corner of our culture.

The man who washes prisoners' feet has never minced words about the length of some sentences, once saying, "Life imprisonment is a hidden death penalty."

He advocates, rather, for healing and a return to society. He made this point strongly to the Philadelphia inmates, "The Lord tells us this clearly with a sign: He washes our feet so we can come back to the table. The table from which he wishes no one to be excluded. The table which is spread for all and to which all of us are invited."

It was Jesus's words of mercy to the tax collector in Matthew 9 that moved then-Jorge, age seventeen, to enter the Jesuits. Mercy, then, has been a theme of his papacy. Prisons, fearful to most, are one of his places of mercy, recalling some other words of Jesus: "For I was...in prison and you visited me."

Thirty thousand male inmates are processed at Curran-Fromhold annually. Pope Francis blesses one of them, promising that he will not be forgotten.

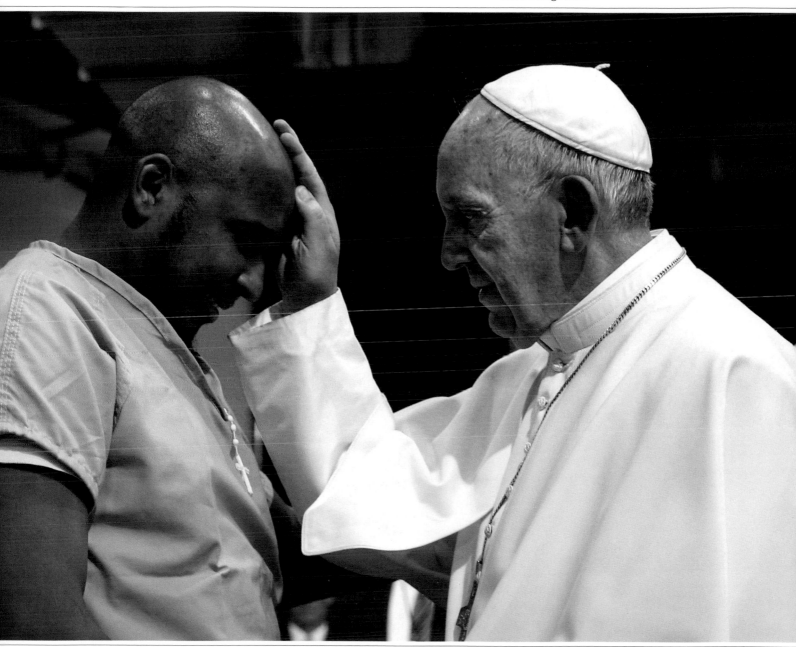

Pope Francis @Pontifex

There is no sin that God cannot pardon. All we need to do is ask for forgiveness.

Inmates and instructors spent four weeks creating and preparing the pope's chair here through PHILACOR, a vocational endeavor that provides learning and job skills.

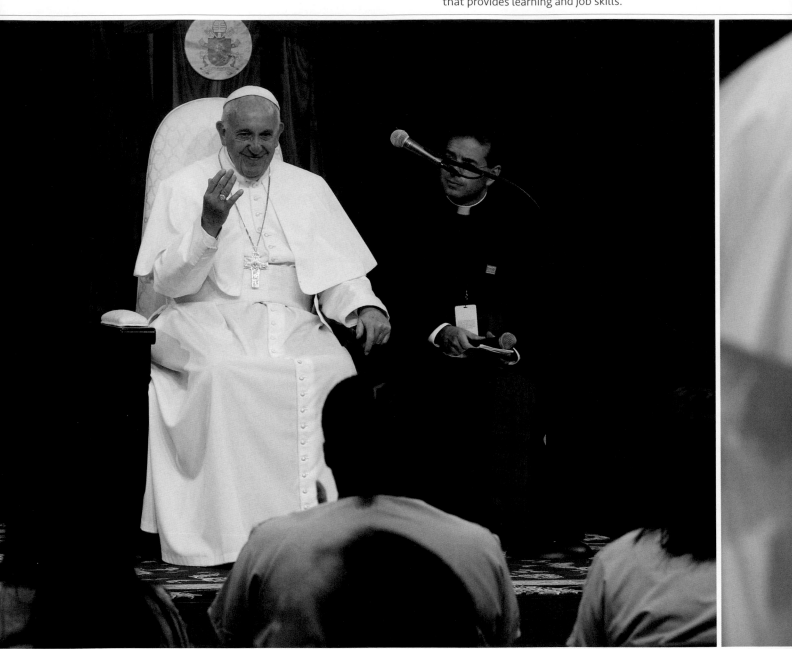

⋎ "It is painful when we see prison systems that are not concerned to care for wounds, to soothe pain, to offer new possibilities," says the pope.

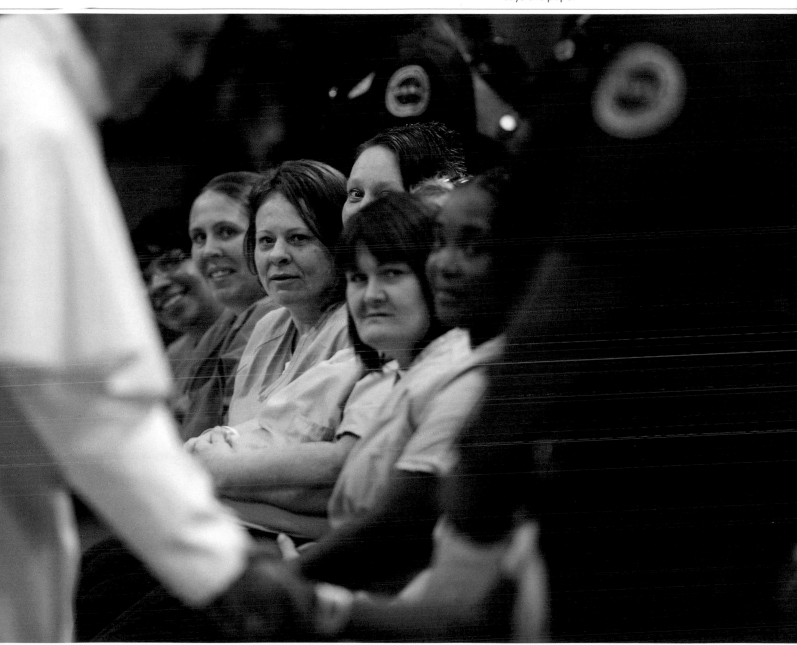

"I am here as a pastor, but above all as a brother, to share your situation and to make it my own."

—POPE FRANCIS AT CURRAN-FROMHOLD CORRECTIONAL FACILITY

Franciscan sisters from Mishawaka, Indiana, pray the rosary before Mass. Their "Mass Pass" will become a treasured memento of this historic event.

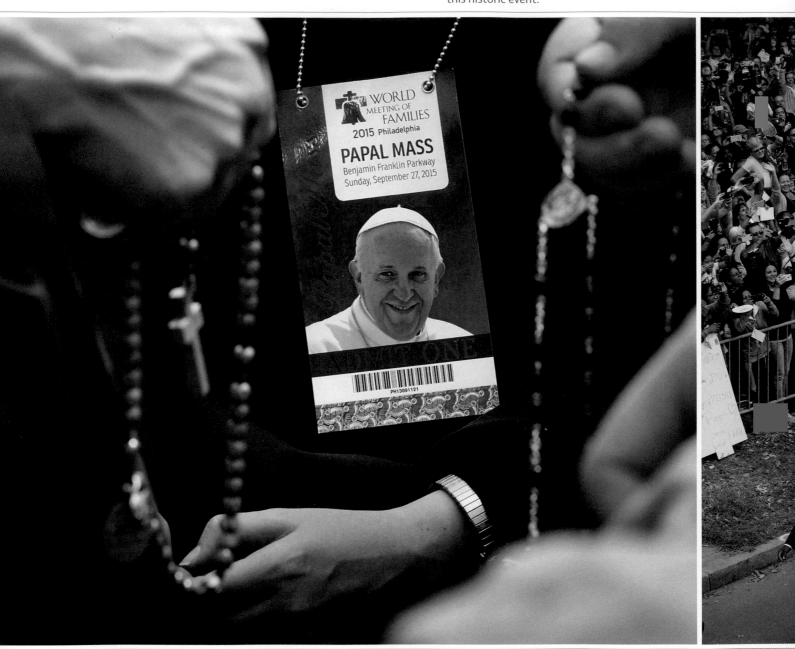

LET US PRAY
THE CLOSING MASS

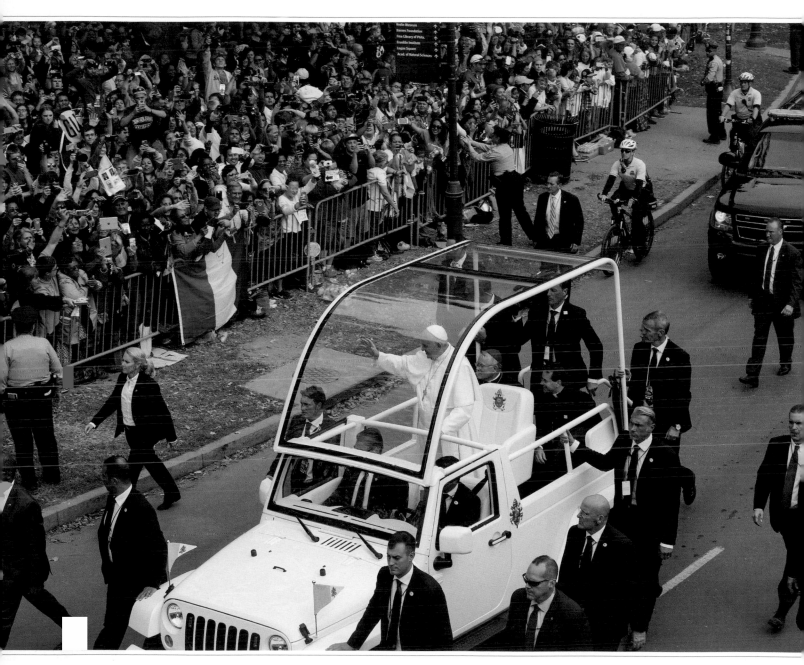

The main celebrant, Pope Francis, on Benjamin Franklin Parkway, is on his way to a Mass attended by an estimated one million people.

▼ Virginia Rivas of New Jersey and Javier and
Maria Leon of Florida sing Marian hymns as
they wait for the closing Mass to begin.

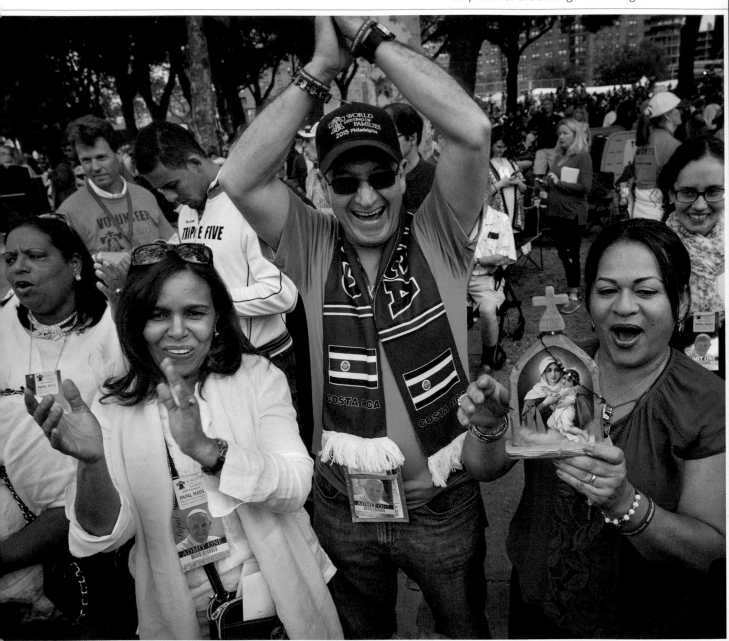

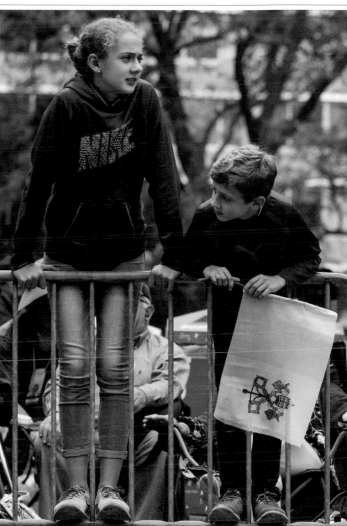

Doug Bauman, a father of three, has come from Indianapolis with his family to join Pope Francis in praying for all families.

Natalia and Karl Braboksi from Tampa, Florida, look over a barrier along Benjamin Franklin Parkway, where Mass will soon begin.

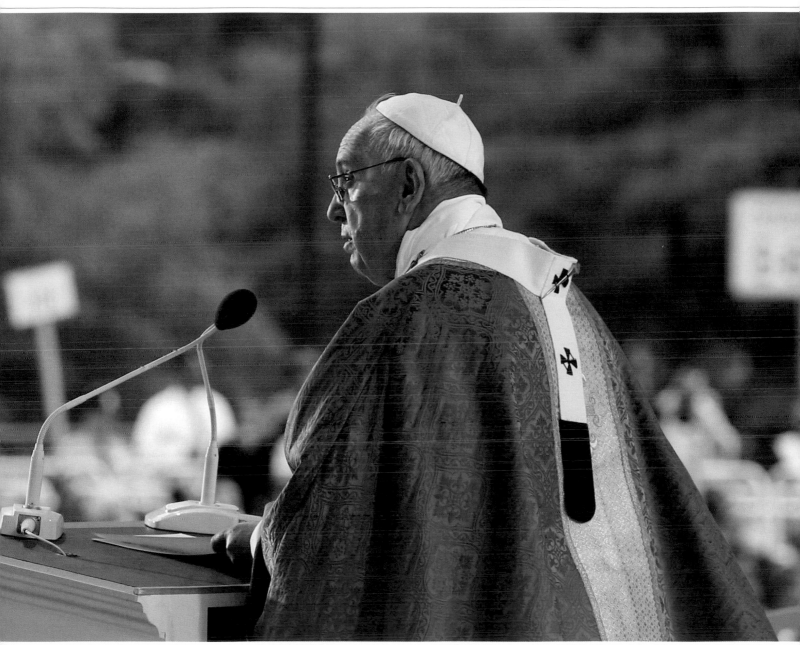

▼ Pope Francis describes families as "the right place for faith to become life, and life to become faith."

Papal Visit by the Numbers

1,000,000
PEOPLE AT CLOSING MASS IN PHILADELPHIA

80,000
TICKETS DISTRIBUTED TO WATCH POPE'S DRIVE
THROUGH NEW YORK'S CENTRAL PARK

50,000
PEOPLE ON U.S. CAPITOL GROUNDS TO SEE THE HOLY FATHER

25,000
PEOPLE AT CANONIZATION MASS IN WASHINGTON, D.C.

11,500
MILES FLOWN, DOOR-TO-DOOR

8,000
POUNDS OF POTATOES BAGGED AND DELIVERED TO D.C. SOUP
KITCHENS BY MEMBERS OF THE CHURCH OF THE ANNUNCIATION

71
INMATES ADDRESSED BY POPE AT PHILADELPHIA'S
CURRAN-FROMHOLD CORRECTIONAL FACILITY

7
WORLD MEETING OF FAMILY CONGRESSES HELD BEFORE 2015

6
FIAT 500LS, THE POPE'S HUMBLE RIDE

2
POPEMOBILES, THE POPE'S PARADE RIDE

1
POPE

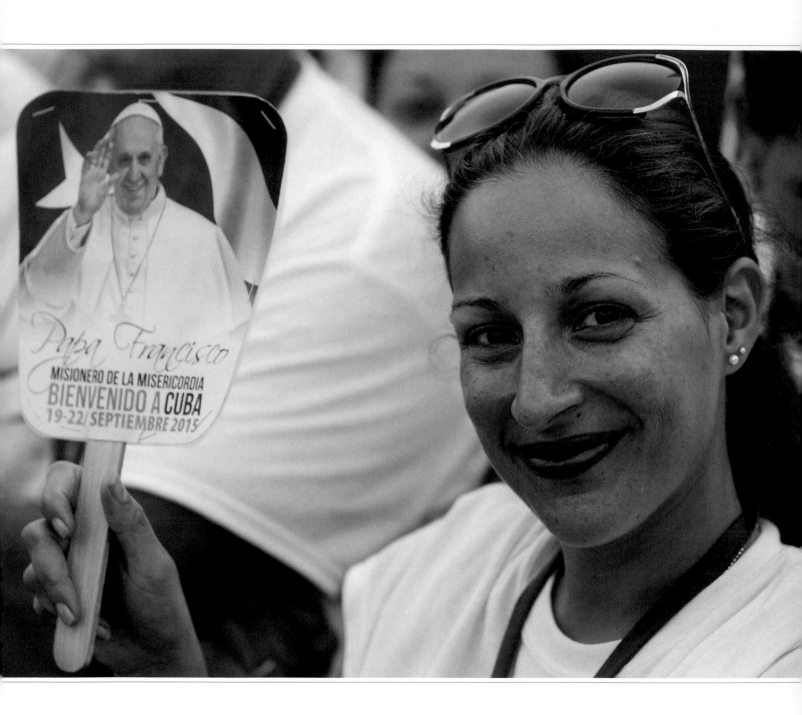

Credits

This book comprises on-the-ground reporting, editing, and photography by Catholic News Service, including text of the papal speeches from Vatican Publishing House, then writing, editing, design, and production by Franciscan Media's magazine and book teams. We are grateful for the support of the U.S. bishops' Catholic Communication Campaign, and the Jasper Family Fund, in honor of Dr. Omer and Martha Jasper, for their support of this project.

CATHOLIC NEWS SERVICE
(U.S. Conference of Catholic Bishops)
Tony Spence, Editor in Chief

Editing team
 Julie Asher
 Edmond Brosnan
 Mary Esslinger
 Mike Farine
 Barb Fraze
 Matthew Kilmurry, Marketing
 Jim Lackey
 Katherine Nuss, Research
 Nancy O'Brien
 Gladys Smith, Coordinator
 Nancy Wiechec

Reporting team
 David Agren
 Angela Cave
 Joyce Duriga
 Ezra Feiser
 Seth Gonzales
 Beth Griffin
 Rhina Guidos
 Laura Ieraci
Constanze Morales
Mark Pattison
Dennis Sadowski
David Sedeno
Wallice de la Vega
Cindy Wooden
Patricia Zapor
Carol Zimmerman

Photo team
Paul Haring, Senior Rome
 Photographer: *10, 12, 13, 15, 16, 17, 19, 22, 23, 24, 27, 29, 31, 35, 42, 43, 44, 47, 49, 50, 51, 56–57, 57, 60, 61, 63, 65, 66, 67, 68, 73, 74, 76, 81, 82, 83, 84, 88–89, 89, 90, 91, 94, 95, 96, 97, 103, 107, 108, 109, 113, 122, 126, 128*
Bob Roller, Senior Washington
 Photographer: *8, 20, 46*
Greg Shemitz: *58, 63, 79, 100–101, 102–103, 103, 104–105, 124*
Joshua Roberts: *24, 25, 30, 88, 110–111, 111*
Lisa Johnston: *28, 92, 93, 120, 121*
Alex Brandon: *36, 37, 39*
Mike Crupi: *77, 78, 79*
Eric Thayer: *70, 71, 75*
Richard Drew: *52, 54, 55*
Rick Musacchio: *4, 39*
Mary Altaffer: *58*
John Beale: *33*
Matt Barrick: *40*
Andrew Burton: *80*
Karen Kasmauski: *34*
Jaclyn Lippelmann: *6*
Doug Mills: *41*
John Paraskevas: *55*
Michael Reynolds: *45*
Craig Ruttle: *55*

FRANCISCAN MEDIA
St. Anthony Messenger magazine team
 John Feister, Editor in Chief
 Jeanne Kortekamp, Art Director
 Pat McCloskey, O.F.M., Franciscan Editor
 Susan Hines-Brigger, Managing Editor
 Christopher Heffron, Associate Editor
 Daniel Imwalle, Assistant Editor

Franciscan Media Book team
 Mark Lombard, Director
 Mark Sullivan, Art Director
 Kathleen M. Carroll, Managing Editor
 Diane M. Houdek, Digital Editor
 Jon M. Sweeney, Editorial Director
 Ray Taylor, Director of Sales and Marketing
 Angela Glassmeyer, Director of Author Relations

Pope Francis @Pontifex

With my heartfelt thanks. May the love of Christ always guide the American people! #GodBlessAmerica